IMAGES
of America

LAKELAND
AFRICAN AMERICANS
IN COLLEGE PARK

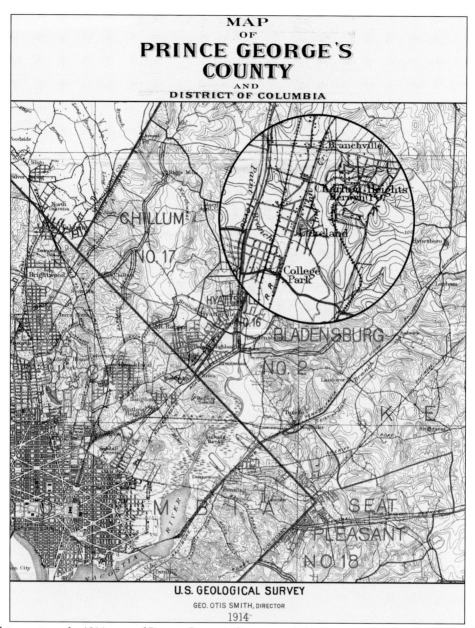

This portion of a 1914 map of Prince George's County and the District of Columbia shows the topography and election districts of the area. In the enlarged section (circle), College Park is near the bottom with Lakeland directly above it. Lake Artemesia can be seen under the "L" in Lakeland. (Courtesy of the National Archives at College Park, Maryland.)

ON THE COVER: Lakeland schools supplemented academic activities with variety shows that helped children develop performance skills and confidence in public speaking. In 1953, students at Lakeland Elementary School performed a Tom Thumb wedding, inspired by the song "The Wedding of the Painted Doll" from the 1929 film *The Broadway Melody*. The school's presentation included Lakeland boys and girls, as well as those who attended the school from other communities along U.S. Route 1. (Courtesy of Jean Gray Matthews.)

IMAGES
of America

LAKELAND
AFRICAN AMERICANS
IN COLLEGE PARK

The Lakeland Community
Heritage Project, Inc.

ARCADIA
PUBLISHING

Published by Arcadia Publishing
Charleston SC, Chicago IL, Portsmouth NH, San Francisco CA

Printed in the United States of America

Library of Congress Control Number: 2008944222

For all general information contact Arcadia Publishing at:
Telephone 843-853-2070
Fax 843-853-0044
E-mail sales@arcadiapublishing.com
For customer service and orders:
Toll-Free 1-888-313-2665

Visit us on the Internet at www.arcadiapublishing.com

*This book is dedicated to the children of Lakeland and
to our parents, grandparents, great-grandparents, and
neighbors who made Lakeland a very special place.*

CONTENTS

ACKNOWLEDGMENTS

We want to acknowledge the contributions from members of the Lakeland community who opened their photograph albums and shared their memories with us. We are grateful to the late Ruth Johnson Taylor Lancaster for her early effort to document the history of Lakeland. Her work was an invaluable resource. A special thank-you goes to the members of the Lakeland Community Heritage Project; it is your support that made this book possible.

We are eternally grateful to the members of the Lakeland Community Heritage Project's book development committee for their dedicated work on this volume. They are Elizabeth Hicks Campbell Adams, Pamela Randall Boardley, James Edwards III, Pearl Lee Campbell Edwards, Janet Randall Gillens, Delphine Gross, Maxine Gross, Violetta Sharps Jones, Charlotte King, Diane Weems Ligon, Jean Ann Gray Matthews, Avis Matthews-Davis, Eli Pousson, and Sandra L. Tyler. We thank the families of these individuals for their forbearance during the months of long nights and countless meetings necessary to complete their work.

INTRODUCTION

This book began as a conversation among longtime Lakeland residents. They reflected upon times gone by and feared the story of their community with its lessons of faith, fortitude, and achievement was being quickly lost. They knew that new residents had no idea Lakeland was a historic African American community with a noble past. Its story had never been documented. In 2007, that group formed the Lakeland Community Heritage Project, Inc. (LCHP), with the goals of preserving and sharing the story of Lakeland. LCHP has since sponsored two Lakeland Heritage Weekends dedicated to celebrating the story of Lakeland. Dozens of volunteers, including family members, former classmates, friends, and neighbors, sat together around tables piled high with photo albums, property maps, and yearbooks, exchanging stories about their lives and experiences in Lakeland. Although additional information was gathered from historic documents, the heart and soul of this book are the images and recollections shared during those first two Lakeland Heritage Weekends.

Lakeland's story mirrors much of the African American experience during legalized segregation in the United States. Located in the South near the District of Columbia but also in close proximity to Baltimore, the community has a narrative that includes elements of Southern life and of African Americans' Great Migration northward in search of wider opportunities. The story of Lakeland is representative of many African American communities that grew and flourished despite the limitations of a less than hospitable society. This book is a portrait of a community and a record of a people living during a pivotal period in our nation's history.

In the late 1890s, Prince George's County, Maryland, was overwhelmingly populated by whites. Early in that decade, developer Edwin A. Newman designed Lakeland to be a resort-style suburban community, although much of the area was wetlands and undesirable for development. At that time, Lakeland's African American residents lived near Paint Branch and Indian Creek, east of the Baltimore and Ohio Railroad tracks, while white residents resided on the western side of that divide. This began to change around the dawn of the 20th century when African Americans John C. Johnson and Joseph Brooks moved their families to new homes in an area west of the railroad tracks. Oral histories tell us that these families endured threats to their lives and property. Over the next several years, nearly all of the white residents left as African Americans continued to arrive to make homes in Lakeland.

Religious life and education were always the backbone of the community and were seen by many as essential for life. By 1903, Lakeland was an established African American community with two churches and a school. Meetings for "song and praise" in individuals' homes led to the establishment of two congregations: First Baptist Church, founded in 1891, and Embry African Methodist Episcopal Church, founded in 1903. Lakelanders opened their community's first school in 1903. Prince George's County Board of Education documents designated it as a school for the "new colored of Lakeland." That school was soon too small to meet the needs of the community and was replaced by a larger structure in 1917. As Lakeland continued to grow, the

Julius Rosenwald Fund, which assisted in the building of more than 5,000 schools for African Americans in the South, helped Lakeland build two more schools, an elementary school in 1925 and a high school in 1928.

Lakeland is centrally located within a group of small interconnected, historic African American communities along U.S. Route 1, from Laurel, Maryland, to the District of Columbia. Tied together by family, education, and recreation, these communities drew together to meet the needs of their residents. In the 1920s, representatives of the communities of Bladensburg, North Brentwood, Ammendale, Muirkirk, and Laurel joined Lakelanders in requesting a high school to serve the area's African Americans. With public funding, money raised within the communities, and additional aid from the Rosenwald Fund, the school was built. In September 1928, Lakeland High School opened with students attending from those communities. From then until 1950, when the student body was moved to a new high school in Fairmount Heights, Maryland, Lakeland High School served as a cultural and social center for African American families throughout northern Prince George's County. Sterling and Bettye Queen, both raised in North Brentwood and graduates of Lakeland High School, explained that attending school together made for a sense of family. Bettye noted that all the "families knew families in Lakeland."

Lakeland's topography and location near Paint Branch and Indian Creek provided an ongoing challenge to the community. Nearly all of the area was within a 100-year flooding zone. However, some sections experienced flooding yearly, resulting in loss of possessions and deterioration of structures. By 1961, a substantial number of homes in the community did not meet modern housing standards. Community leaders sought help from the city government. After much study and consultation with Lakelanders, the City of College Park requested federal government help in the form of flood control and funding for redevelopment and home renovations. The request ultimately resulted in the Lakeland Urban Renewal Plan, approved by the city in 1970.

When the topic of urban renewal has been brought up during the documentation of oral histories, volunteers conducting the interviews have encountered long pauses, curt summaries, and unexpected omissions from Lakelanders who recall the experience. From the 1960s through the mid-1980s, the urban renewal process in Lakeland demolished many family homes, displaced 104 of 150 households, and replaced much of the neighborhood with a mix of subsidized townhouses, high-density apartments largely inhabited by students, and an elder housing facility. Few of the many families forced to leave during construction could resettle in Lakeland. The depth of this loss continues to affect heritage preservation in Lakeland, as current residents in the City of College Park and the surrounding area often have no knowledge of Lakeland and its unique history. However, Lakeland residents are proving their resiliency by their active commitment to sharing and preserving their own history, as is reflected in this verse of a 1987 poem by Lakelander Shirley Randall Anderson:

> Our Lovely Town, O Lakeland Town
> Of maples, elms and oaks.
> A quiet town, a peaceful town,
> Of kind and gentle folks.
> Our fathers stood with strength
> And faith, to make this township stand.
> We love this strand of quiet land.
> O Lakeland Lakeland Town!

One

Building a Community

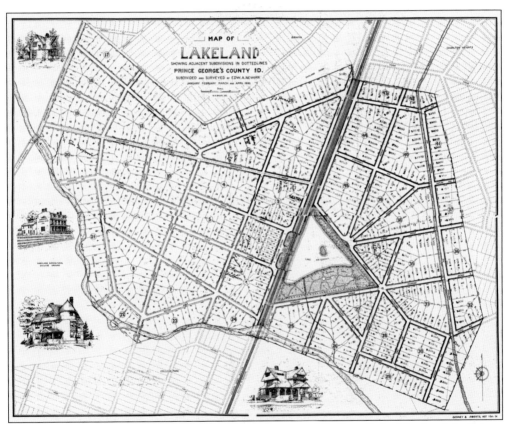

Lakeland is the historic African American community of College Park, Maryland, in Prince George's County. African Americans first made their homes in Lakeland near Indian Creek on the eastern side of the Baltimore and Ohio Railroad tracks. The community was developed by Edwin A. Newman in the 1890s as a resort-style community for white residents. This map shows Newman's rather grand original plan for the subdivision. The large railroad station, park, and fountain were never built, and much of the land shown as lots was wetlands. (Courtesy of the City of College Park, Maryland.)

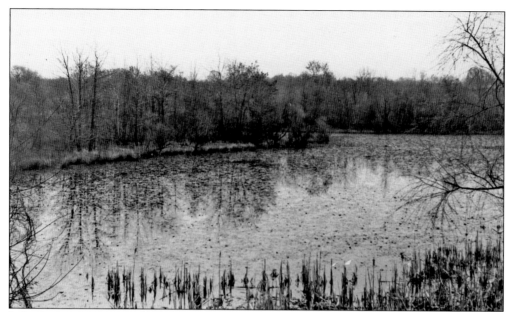

Lake Artemesia was initially dug in the mid-19th century by the Baltimore and Ohio Railroad to retrieve gravel for use as ballast. It was later developed for recreational use by Edwin A. Newman in the 1890s. The lake was a center of recreation for the community, with swimming and fishing in summer and skating in winter. The lake was also the site of breeding ponds for the Baltimore Goldfish Company and later the U.S. Bureau of Fisheries. (Courtesy of the Gross family.)

In 1835, the Washington branch of the Baltimore and Ohio Railroad became an important part of the landscape when it opened and bisected the area that became Lakeland. By the early 1900s, the railroad was a major source of communication, transportation, and employment for the residents of the area. (Courtesy of the Gross family.)

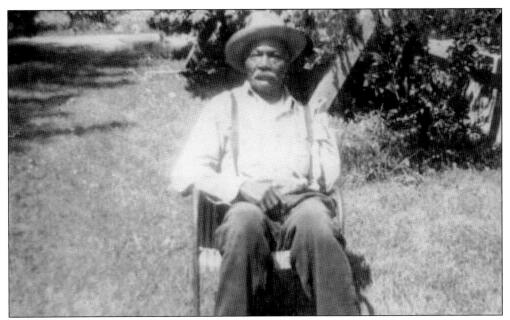

Joseph G. Brooks was born in 1871 and married his wife, Rosa, in 1896. The 1910 census lists him as living in a mortgage-free home on Lakeland Road with his wife and seven children. Oral history tells that he lost his arm in an accident while working with a rail-switching operation. Around the opening of the 20th century, the Brooks and Johnson families moved from the eastern section of Lakeland to the central section, an area populated by whites. (Courtesy of Dwight Brooks.)

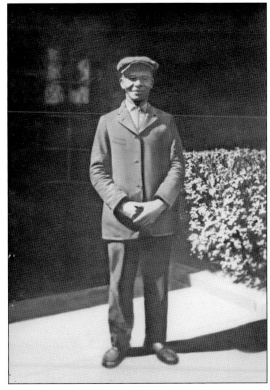

John Calvary Johnson came to Lakeland with his wife, Sarah Butler Johnson, and his mother around 1890. They, along with the Brooks family, were the earliest African American residents to live on the west side of the railroad tracks in Lakeland. Johnson was a prime mover in the establishment of the First Baptist Church and the first school in the community. All five of his children were born in Lakeland. His eldest child, Mary, known as "Mamie," was born in 1892 and remained in the community until her death in 1976. (Courtesy of Roy Few.)

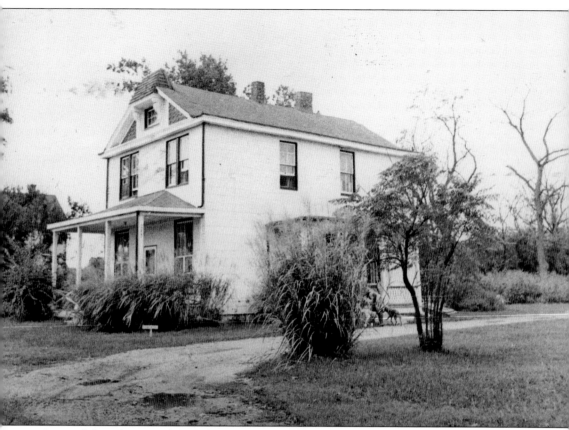

Located directly across from Lake Artemesia and the Baltimore and Ohio Railroad tracks, the Gray family home was for more than 60 years the site of many gatherings for family and friends. The family began hosting elementary students in 1909 when space in Lakeland's one-room school became inadequate. From 1909 to 1917, a post office and rail stop operated within the home. Paint Branch Elementary School now stands on the property. (Courtesy of Thelma Lomax.)

James Henry Gray was born in Calvert County, Maryland, in 1865, the year the Civil War ended. He and his wife, Eliza E. Gray, first lived in neighboring Berwyn, where their eldest son, William, was born in 1896. The family moved to Lakeland soon thereafter. Gray, called "Pop" by his family, was on the ministerial staff at Dent Chapel AME Church in Bladensburg, Maryland. In his later years, he worshipped with family members at Lakeland's Embry African Methodist Episcopal Church. "Pop would make us have prayer *before* we went to church," his granddaughter Jean Gray Matthews remembers. "We'd be kneeling on the living room floor, and Pop would pray so long, we'd feel like we'd already been to church!" Some of the couple's descendants remain in the community and maintain active membership at Embry AME Church. (Both courtesy of the Gray family.)

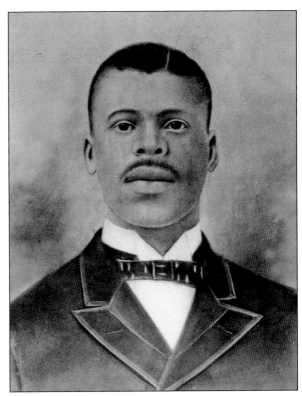

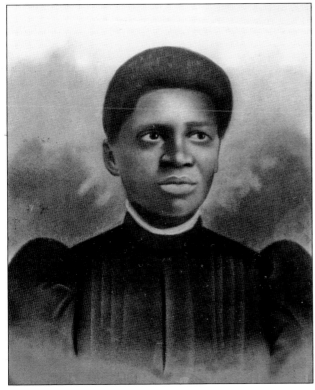

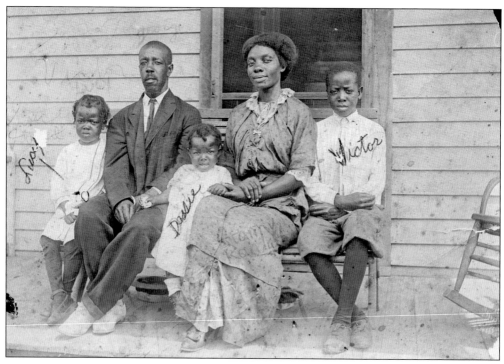

George Randall and his wife, Ellen Hunter Randall, met when she came to Lakeland from North Carolina to work as a caretaker in a local home. They are posed with their three eldest children who are, from left to right, Lucy, Dessie, and Victor, around 1913. The pair later parented four more children, who grew up and raised families in Lakeland. (Courtesy of the Randall family.)

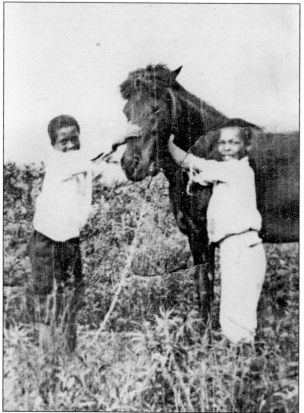

Alfred Gross (left) and Horace Brooks (right) are pictured here around 1910. The horse is believed to have been owned by Ferdinand Hughes, an uncle of Gross. Hughes farmed a nearby parcel of land and used a horse-drawn wagon to transport his produce to the District of Columbia for sale. (Courtesy of the Gross family.)

George Isaac Walls moved to Lakeland at the turn of the 20th century from Westmoreland County, Virginia. Walls came with his mother and siblings to join his maternal aunt in Lakeland. On November 18, 1904, he married Hattie Dyce in one of the early weddings at Embry AME Chapel. In 1911, they built a home that still stands on Navahoe Street. There they raised four children. Here he is shown around 1915. Many of their descendants remain in the community. (Courtesy of Diane Weems Ligon.)

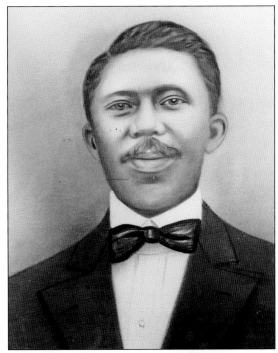

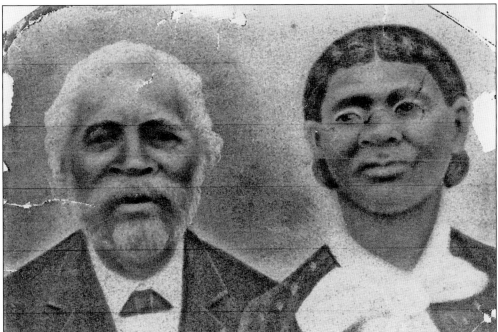

James Johnson and Nannie Walls Johnson were two of Lakeland's earliest African American residents. They migrated with family members from Westmoreland County, Virginia, between 1890 and 1900. This photograph is from that period. In 1900, they were living in Lakeland with their six children: Lucy, Susan, Rosie, Mary, James, and Charles. Their last-born son, Clifton, was born in Lakeland in September 1909. Descendants of this family still live in Lakeland. (Courtesy of Shirley Tyner Pratt.)

The home of Benjamin Robert Hicks and his wife, Annie L. Terry Hicks, was located on Washington Street (now Lakeland Road) next to the old Lakeland High School. In addition to welcoming visiting ministers, the Hickses also rented rooms to newcomers in the community. This photograph was taken prior to the building of the school in 1928. The house was demolished in the early 1960s. (Courtesy of Elizabeth Hicks Campbell Adams.)

Benjamin Robert Hicks was born on March 24, 1873. In 1900, he migrated from Calvert County, Maryland, to seek employment. He settled in Lakeland, where he met and married Annie L. Terry. She was born in 1873 in the Gainesville-Centerville area of Virginia. They raised three children: Ethel, Madeline, and Maurice. Hicks was a founder of Embry AME Chapel and a deacon of the church. He was employed as a member of a crew that maintained the tracks of the nearby Baltimore and Ohio Railroad. Annie was a homemaker and laundress. (Both courtesy of Elizabeth Hicks Campbell Adams.)

Between 1910 and 1918, the Guss family moved from St. Mary's County, Maryland, to Lakeland by way of the District of Columbia. The family house on Lakeland Road is one of the oldest in the area. Shortly after they arrived, Cornelius and Carrie Guss bought the property from its white owner. They were one of a number of Roman Catholic families in the community and reared their children, Amos and Sadie, in that faith. (Courtesy of Anna Greene.)

This formal portrait of Amos Guss in spats, with his signature cigar, was taken around 1925. Guss was one of Lakeland's longest-surviving World War I veterans. In January 1919, at the age of 22, he was honorably discharged from the U.S. Army. For the next 70 years, he spoke proudly of his military service and was an active member of the American Legion. (Courtesy of Thelma Lomax.)

Charles Hamlett is shown with his first wife, Eva, around 1930. He came from New Jersey to Lakeland and married Eva Brooks in the late 1920s. She was the daughter of two of Lakeland's earliest African American residents, John and Maggie Brooks. They built a house near her parents' home in the area of Lake Artemesia. That home became a victim of urban renewal. As with many early Lakeland families, the Hamletts have descendants in the community. (Courtesy of Mary Hamlett Harding.)

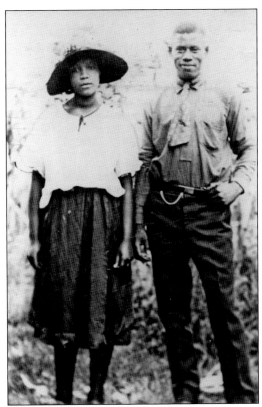

The home of Charles Hamlett and his second wife, Nettie Edwards Hamlett, was located on Cleveland Avenue near a small group of lakes that once served as breeding ponds for the Baltimore Goldfish Company and later the U.S. Bureau of Fisheries. Originally their property contained a single home. Over time, additional structures were added to the property for use as rental units. These served as ideal homes for newcomers to the community. (Courtesy of Thelma Lomax.)

19

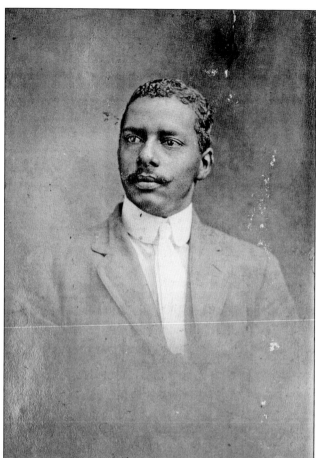

Charles "Duck" Russell moved to Lakeland in the early 1900s to raise his family. After becoming a widower, he remarried and raised a second family. Russell worked for the City and Suburban Railway of Washington on the streetcar line that passed through Lakeland. His residence was located on the east side of the railroad tracks near Lake Artemesia. Some of Russell's descendants still live in the community. (Courtesy of Magdalene Johnson.)

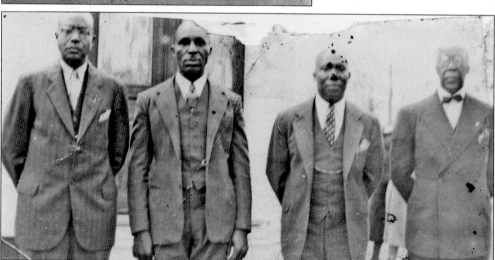

By the 1940s, a second generation of patriarchs and homeowners had matured in Lakeland. This new generation of community leaders included, from left to right, Benjamin Briscoe Sr., George Brooks Sr., Arthur Brooks, and J. Chesley Mack. These gentlemen married local ladies and were prominent in the community. (Courtesy of the Randall family.)

Two

THE KEY TO THE DREAM

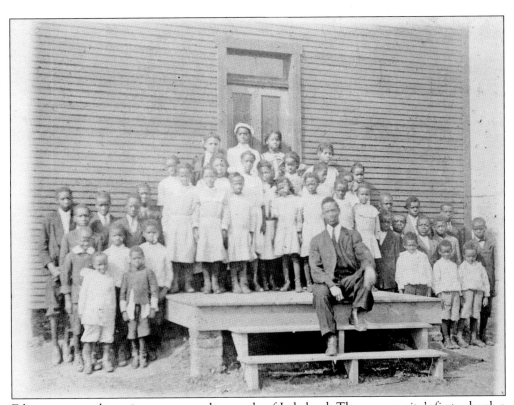

Education was always important to the people of Lakeland. The community's first school, a one-room elementary school, was established in 1903. The original building remained in use until 1917, when it was replaced by a two-classroom structure. This c. 1915 photograph shows students at the school with one of their teachers, George G. Waters. (Courtesy of Elizabeth Hicks Campbell Adams.)

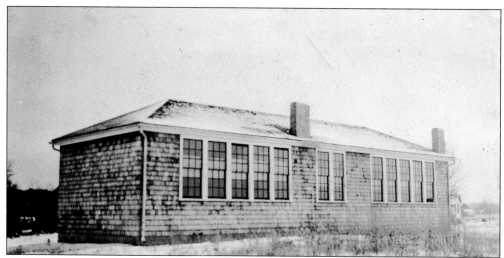

From 1917 to 1932, the Rosenwald Fund contributed to the building of approximately 5,000 schools for African American children in Southern states. The Rosenwald program provided state-of-the-art school plans along with partial funding. Communities were required to provide cash or in-kind contributions; the remainder of the school costs was borne by local school boards. Lakeland had two such schools. Lakeland Elementary (shown above) was built in 1925, replacing the earlier school; and Lakeland High School was built in 1928. Lakeland joined with neighboring communities to request that the school board approve construction of a high school for African Americans. Lakeland was selected as the site for the new high school because of its central location and the availability of train transportation. Shown below are the young women of the 1930 Lakeland High School student body. (Above courtesy of Fisk University Franklin Library Special Collections; below courtesy of Diane Weems Ligon.)

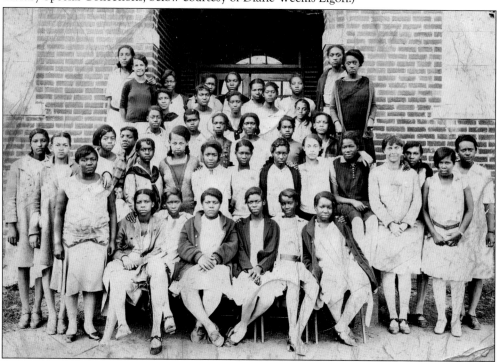

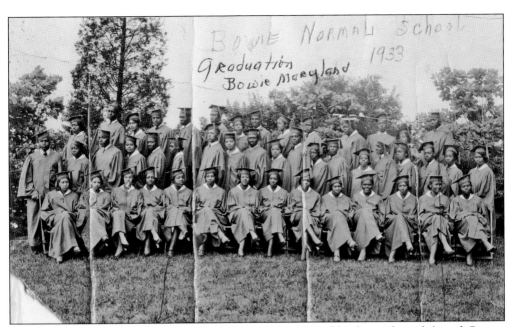

Dessie Randall (first row, fifth from left), James Edwards Jr. (third row, far right), and George Arnold are pictured here with other members of the 1933 graduating class of Bowie Normal School. Randall was one of the first Lakelanders to seek a post-secondary education. She was a member of the first graduating class of Lakeland High School in 1931. Edwards later moved to Lakeland and raised his family in the community. Arnold taught at Lakeland High School and died in a car accident after a picnic at Carr's Beach with friends from Lakeland. (Courtesy of the Randall family.)

Born in 1902, the youngest child of John C. Johnson, Ruth Johnson Taylor-Lancaster was educated in the District of Columbia public schools. She earned a teaching certificate from Bowie Normal School and a Bachelor of Arts degree from Delaware State College. During the 1930s, she spearheaded efforts to bring preschool, after-school, and adult education to Lakeland. In 1936, Lancaster taught Lakeland's first adult education classes. In her later years, she was a founder of the Lakeland Senior Citizens Club and wrote the first history of the community. (Courtesy of Patricia Barber Williams.)

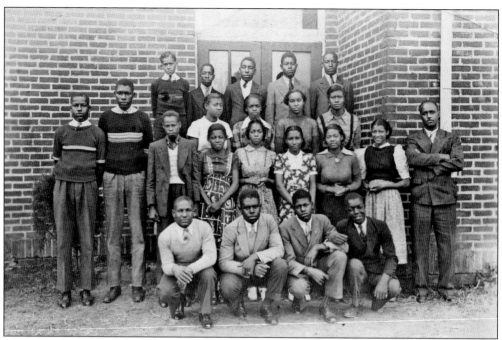

Principal Edgar A. Smith is pictured here with the 1938 senior class of Lakeland High School. Smith was appointed principal of Lakeland High School when the school opened in 1928. He held the position until 1966, through its transition to a junior high and later to an elementary school. During much of this period, he also served as a classroom teacher. Even with these responsibilities, Smith completed his master's degree at Temple University. (Courtesy of Leonard Smith.)

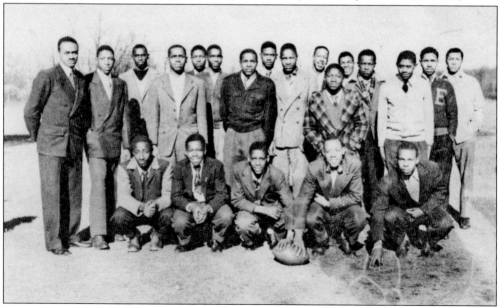

Coach Estee B. Wells and cocaptains, kneeling with the football, Robert Moore (left) and Elijah Norris (right) led the Lakeland High School football squad to a second undefeated season and the state football championship in 1946. Pictured on the field at Lakeland High School are the coach and members of the football team. (Courtesy of Jean Gray Matthews.)

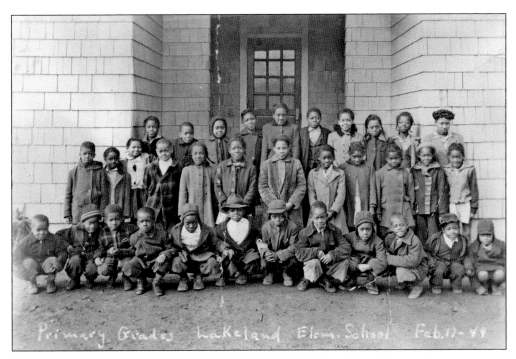

For more than 30 years, the first school attended by most Lakelanders was Lakeland Elementary School on Winnipeg Street. It had two classrooms heated by a potbelly stove and an outhouse near the building. In 1944, the primary class, grades one through three, were taught by Margaret Wills in one classroom; and the upper class, grades four through six, were taught by Anita P. Smith in the second classroom. Lakelander Bessie Mack often worked as a substitute teacher at the school. (Above courtesy of Leonard Smith; below courtesy of Elmore Adams.)

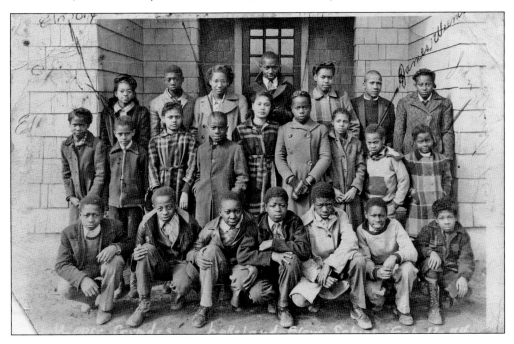

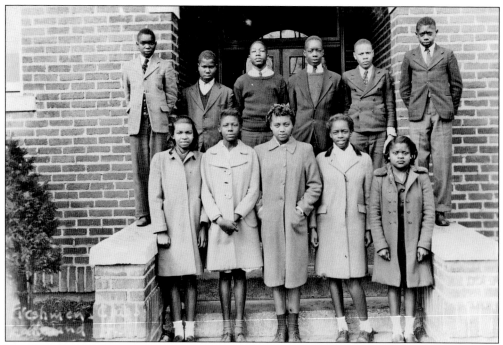

The freshman class at Lakeland High School posed in front of the school in 1943. By this time, the county school buses were bringing students to Lakeland from the other African American communities along the U.S. Route 1 corridor, from Mount Rainier to Laurel. After 1946, students also were bused from the Highland Park area of the county until Fairmont Heights Junior-Senior High School opened in 1950. (Courtesy of Mary Day Hollomand.)

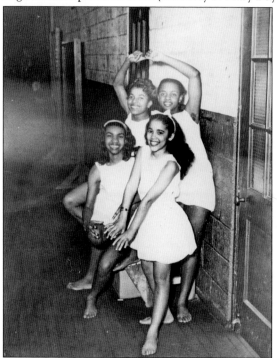

Four members of the Lakeland High School Dance Group posed in the school hallway in 1946. Dance, music, and athletics were offered at the school. Teachers donated time to the community and often taught extracurricular programs after school. Educators defined their roles as providing more than classroom learning; they worked to expand the cultural horizons of students as well. Lakeland High School Dance Group president Mary Day (left) and secretary LaVerne Tolson (rear, right) are pictured with other members of the group. (Courtesy of Diane Weems Ligon.)

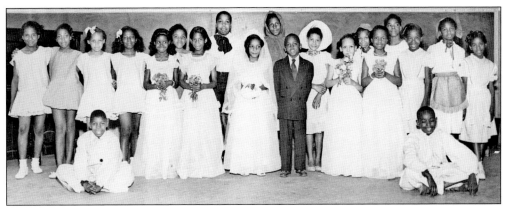

Lakeland schools supplemented academic activities with variety shows that helped children develop performance skills and confidence in public speaking. In 1953, students at Lakeland Elementary School performed a Tom Thumb wedding, inspired by the song "The Wedding of the Painted Doll" from the 1929 film *The Broadway Melody*. The school's presentation included Lakeland boys and girls, as well as those who attended the school from other communities along U.S. Route 1. (Courtesy of Jean Gray Matthews.)

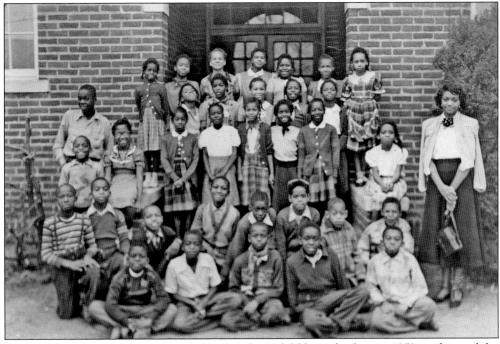

Edwina Herald Buckner stands with her fourth- and fifth-grade class in 1953, in front of the Lakeland Elementary and Junior High School. The third- through sixth-grade classes were housed in metal-clad temporary buildings behind the older brick building. In addition to her classroom duties, Buckner offered free ballet lessons after school. (Courtesy of the Randall family.)

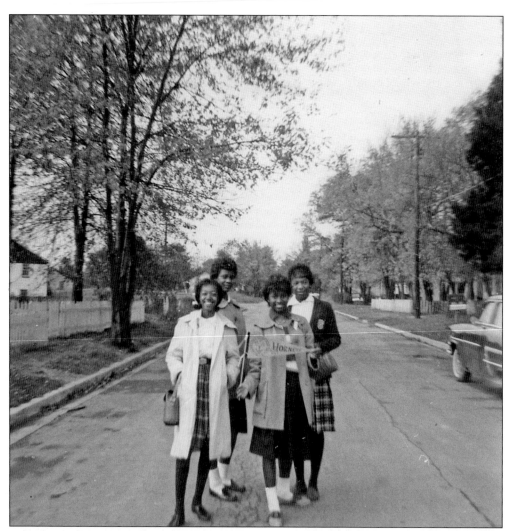

School girls, from left to right, (first row) Pamela Sharps and Pearl Lee Campbell; (second row) Mary Ann Campbell and Pamela Randall wave their Fairmont Heights Hornets pennant as they prepare to leave Lakeland to support their team during the school's 1960 homecoming game. Lakeland High School was replaced by Fairmont Heights Junior-Senior High School in 1950. The new school served the African American students from widely scattered areas of Prince George's County. As a result of the 1964 Civil Rights Act, the school board abandoned its earlier, race-based school assignment plan and instituted a system based on residential boundaries. At the time, housing in Prince George's County was segregated. African Americans resided in single-race communities, many out of custom and by choice and others because of housing discrimination. The result of the new boundaries plan was a school system with mostly single-race schools. There was a policy, however, that allowed students to seek assignment to other schools. Few sought that option. In the 1960s, Lakeland students were assigned to the closer, predominantly white Northwestern High School in Hyattsville and High Point High School in Beltsville. (Courtesy of Pearl Lee Campbell and James Edwards III.)

In 1960, Dervey and Thelma Lomax sought to enroll their son Gregory in a nearby, predominantly white elementary school, but the school board denied his admission. After a second denial a year later, the Lomax family, with the assistance of the local NAACP, appealed to the state board of education. The local board settled by admitting Gregory as a second-grader to the predominantly white College Park Elementary School. The following year, he was joined at school by his younger brother Elston and a few other young Lakelanders. Above, Gregory Lomax is shown as an elementary school student. The 1966 fourth-grade class of College Park Elementary school is shown below. Elston Lomax is seated in the first row, third from the left. Fellow Lakelander Romonia Sellers is next to him. Wayne Claiborne is standing in the last row, second from the right. (Both courtesy of Thelma Lomax.)

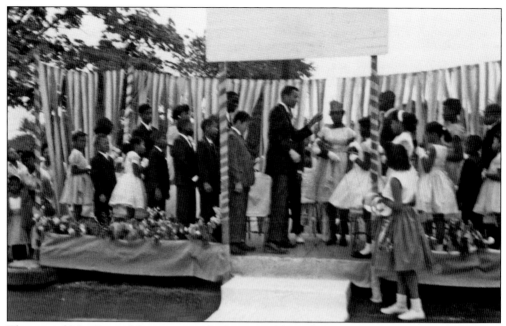

The annual May Day celebration was a high point of the Lakeland school year for many decades. Parents came to witness the daylong festivities, which included sporting matches and a musical program. The day's highlight was the children dancing around the maypole. Here the May Queen was crowned around 1960. (Photograph © 2008 Joanne M. Braxton.)

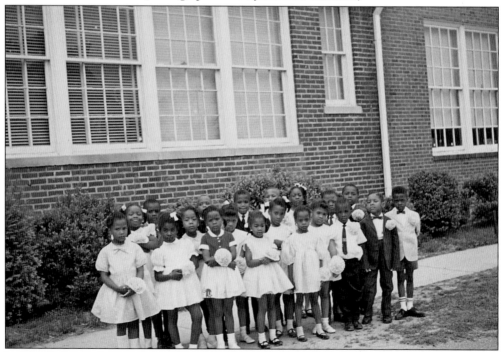

Lakeland's first kindergarten classes were taught during the 1930s by Ruth Johnson Taylor Lancaster. Kindergarten was then discontinued at the school until the 1960s. Here the 1965–1966 kindergarten class poses during the school's May Day celebration. (Courtesy of the Gross family.)

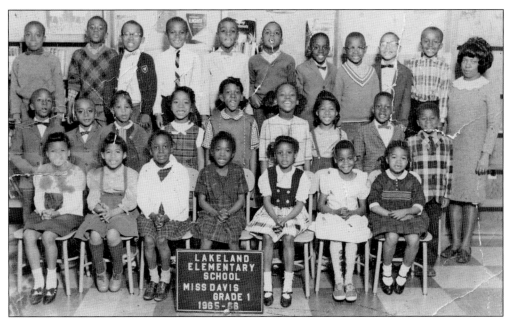

For most of a century, only African American students attended school in Lakeland. In 1956, two years after the U.S. Supreme Court ruled that segregated schools were unconstitutional, the Prince George's County Board of Education enacted a plan to impede the integration of schools. The first white students did not attend Lakeland Elementary School until the late 1960s. They were few in number. Nevertheless, desegregation progressed intermittently until court-ordered programs began in 1973. Pictured in these photographs, taken during the 1966–1967 school year, are (above) Lakeland Elementary School's first-grade class with their teacher, Armandia Davis, and (below) the fourth- and fifth-grade class with their teacher, Mr. Ford. (Above courtesy of the Gross family; below courtesy of Elizabeth Hicks Campbell Adams.)

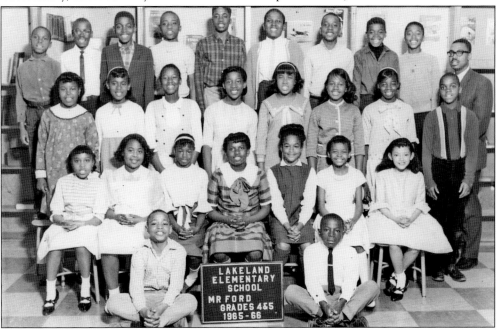

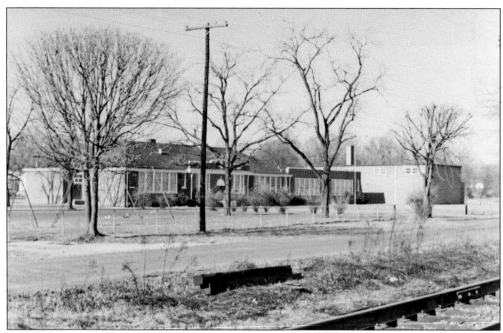

The historic Lakeland High School began in 1928 with six classrooms. It was expanded in the 1940s with additional classrooms and again in the 1950s when a multipurpose room was added. That building served the community's schoolchildren from 1928 until 1972. It functioned as a high school until 1950, as an elementary and junior high school until 1962, and as an elementary school until 1972. The school board later used the building as a special education center. (Courtesy of Thelma Lomax.)

African Americans could not attend the University of Maryland until 1954, and few undergraduates of color were admitted until the 1970s. Lakelander Constance Sandidge graduated from the University of Maryland at College Park in 1969. About her graduation, she wrote, "I had no idea that I was doing anything out of the ordinary. Our parents instilled in my sisters and me that we could be successful at anything, and they made unbelievable sacrifices to ensure that we would get a firm academic foundation." (Courtesy of Constance Sandidge.)

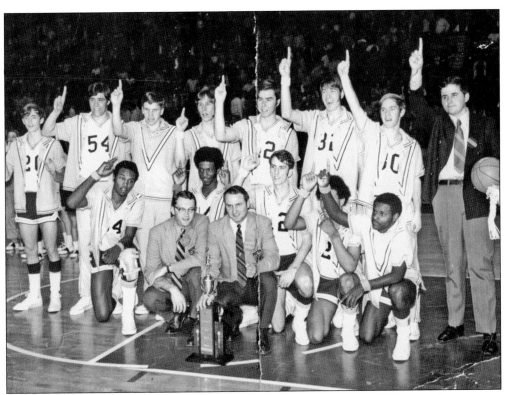

Lakelanders, from left to right, Jeffrey Briscoe, George Randall, Douglas Few, and James Gray were Lakeland's favorite sons in 1971, when they led Parkdale High School's Panthers to a state basketball title. Briscoe, Gray, and Randall were members of the first class of Lakeland students to attend the new high school. They had sharpened their skills in Lakeland's schoolyard and as teammates at Greenbelt Junior High School. (Courtesy of Jean Gray Matthews.)

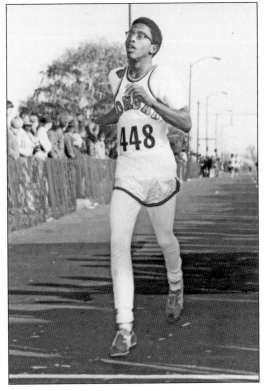

As a freshman at Morgan State University in Baltimore in 1974, Robert Peterson participated in the Maryland Marathon, completing the Olympic distance of 26 miles, 385 yards in 3 hours, 19 minutes, 31 seconds. The next spring, Peterson ran the Boston Marathon. He is still a runner and can be seen out for a run any day. (Courtesy of the Randall family.)

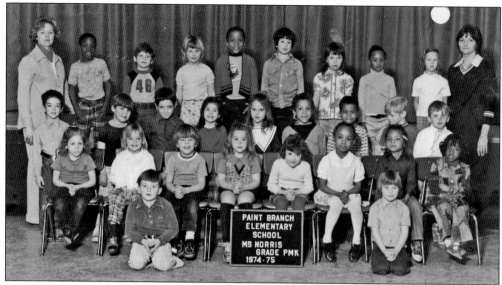

By the late 1960s, Lakeland Elementary School's student body was still overwhelmingly African American. The faculty had been integrated during that decade and local leaders were still engaged in the fight for full integration. The next step in that process was the redrawing of school boundaries. This new plan required a larger school facility. Lakelanders sought to have this new fully, integrated school within Lakeland. This commitment was maintained despite the school board's selection of a site in Lakeland occupied by houses. Even some of those who would be losing their homes worked actively for a new school in Lakeland. Paint Branch Elementary School opened in 1972 as an integrated elementary school with students from Lakeland and neighboring communities, the result of activism of Lakelanders and other local residents. Shown above is Miss Norris's prekindergarten class in 1974–1975. Today the school serves more than 350 students from prekindergarten through sixth grade. (Above courtesy of Earlene Williams; below courtesy of Bryan Haynes/*The Gazette*.)

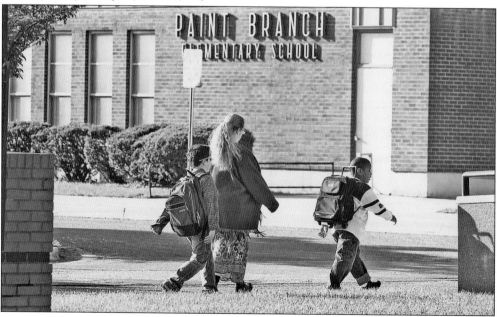

Three

SUSTAINED BY FAITH

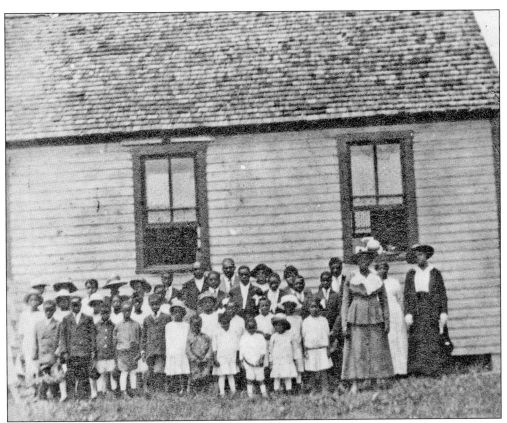

In 1890, African American Christians in Lakeland began to gather for worship in the homes of community members. From these meetings, two congregations were born, the First Baptist Church of Lakeland (later College Park) in 1891 and the Embry African Methodist Episcopal Chapel (later Church) in 1903. Gathered in this turn-of-the-20th-century photograph is a group of parishioners outside of the First Baptist Church of Lakeland. (Courtesy of Elizabeth Hicks Campbell Adams.)

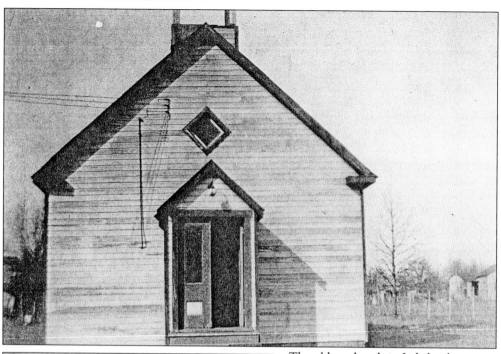

Come and Go with Us! **Where To?**

Suburban Gardens

The First Baptist and Emory A. M.

E. Sunday Schools will give a

Union Picnic

Sat., Aug. 22,

Committee

Mr. George W. Randall	Mrs. Susie Briscoe	Mr. Charles Dory
Mrs. Mary E. Johnson	Mrs. Mary A. Brooks	Mr J. C. Johnson
	Mr. S. J. Lewis	
Rev. Franklin P. Turner, Jr., Pastor.		Rev. G W. M. Lucas, Pastor.

Cars leaves Lakeland 9.30 A. M. **Returning 6 P. M.**

Admission :-: 50 Cents

"The Never Idle Printer"

The oldest church in Lakeland was organized in 1891. Congregants purchased a building near the Paint Branch Creek, between the Baltimore and Ohio Railroad tracks and the streetcar line. The building was renovated, a cornerstone was laid, and it became the First Baptist Church of Lakeland. While the church was under construction, services were held in the homes of Larkin Johnson, Oliver Johnson, Monroe Richmond, and the Robinson family. (Courtesy of First Baptist Church of College Park.)

This flyer advertises the 1925 Union picnic. For many years, the First Baptist Church and Embry African Methodist Episcopal Church sponsored a joint annual Sunday school picnic. It was held at Suburban Gardens in the Deanwood neighborhood of the District of Columbia. Unlike others, the 7-acre amusement park welcomed African American visitors to enjoy the roller coaster, Ferris wheel, swimming pools, and picnic grounds. (Courtesy of Jean Gray Matthews.)

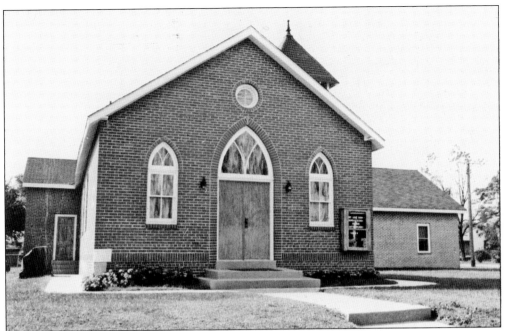

Embry AME Church was founded in 1903 in the home of Samuel and Georgianna Stewart. The congregation built a chapel in 1905 in a low-lying section of the community. In 1918, the building was moved to a site on Lakeland Road. In 1920, a new church on the same location replaced the chapel. Over time, a parish hall and study were added. The building is shown here around 1965. (Courtesy of Thelma Lomax.)

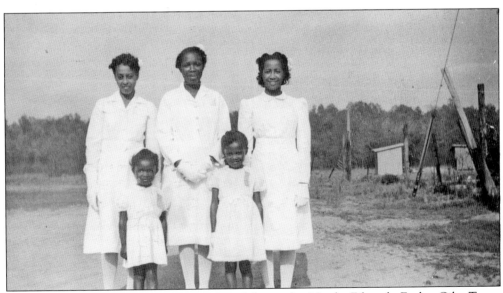

On a summer Sunday morning in 1942, from left to right, Martha Edwards, Evelyn Giles Tyner, and Tyner's sister, Lucille Giles (ushers for Embry AME Church), walked to church with Tyner's daughters, Edna and Shirley. The Edwards garden is visible on the left; the Giles house is off to the right. (Courtesy of Mary Hamlett Harding.)

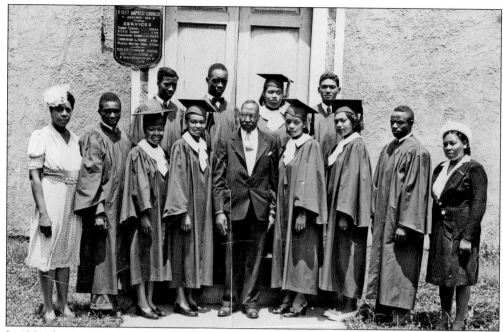

In 1901, the First Baptist Church purchased a parcel of land from church deacon John C. Johnson, and the church was relocated to its current location on Lakeland Road. This move proved beneficial to the community when the church was able to provide needed classroom space for the overcrowded Lakeland Elementary School. Here members of the Junior Choir posed in front of the church around 1945. From left to right are (first row) pianist Mary Brooks Brewer, Hurley Brooks, Elaine Brown, Mary Day, Pastor J. A. Franklin, Serville Russell, Norman Lockerman, and Elsie Moody; (second row) Rudolph Gross, John Hamlet, Mary Hamlet, and Norwood Walls. (Courtesy of First Baptist Church of College Park.)

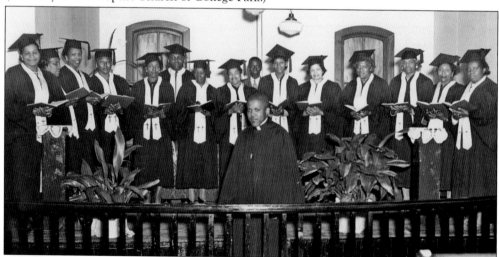

The Reverend Jessie Williams and the Embry Choir gathered for this photograph on April 27, 1948. Members of the choir are, from left to right, Mary Daisy Briscoe, Mattie Johnson, Evelyn Tyner, Agnes Gross, Willa Mae Smith, James Edwards Jr., Dora Robinson, Annabelle Stroud, Leon Robinson, Amy Potts, Ellen Briscoe, Emma Harrison, Maggie Mack, Ila Mason, and Hazel Thomas. (Courtesy of Jean Gray Matthews.)

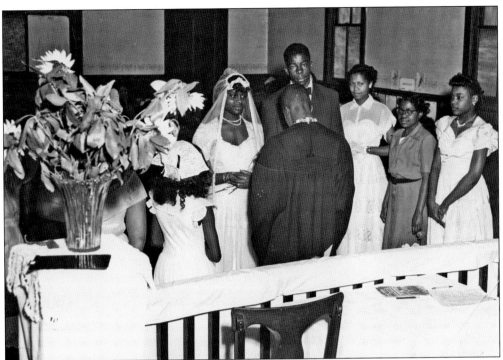

Mock weddings such as this one at Embry AME Church, around 1949, were popular dramatizations and fund-raisers for churches. The church's youth played the parts of bride, groom, minister, and wedding party. Embry maintained an active Sunday school, providing a Christian foundation and a social outlet for many children in the community. Embry also was active in the AME Church's Potomac District Sunday School Council. Sunday school superintendent Dessie Randall Thomas loaned her wedding dress for this activity. Jean Gray and Ellsworth Dory, both about age 15, are the bride and groom. (Both courtesy of the Randall family.)

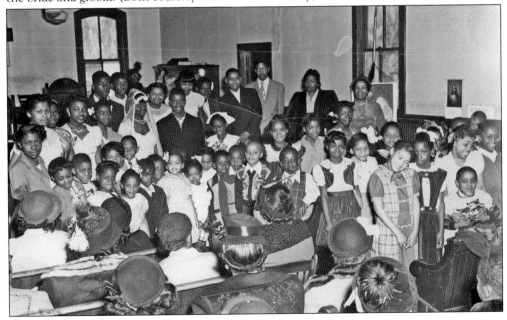

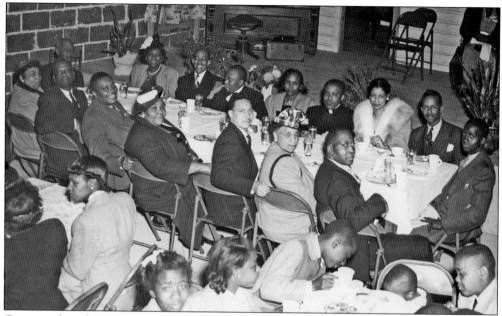

Communal meals are a traditional part of celebrations at Lakeland's churches. Members of Embry AME Church have lunch in their parish hall following a Sunday service in 1943. Among those at the table are the pastor, Rev. Jesse A. Williams (wearing the collar), and his wife, Fannie, seated to his right; and former pastor Rev. Herman R. Curtis and his wife, Laura (far side of the table, first and second from the left). At the head of the table to the right is Leon Robinson, a longtime church member and trustee. (Courtesy of Jean Gray Matthews.)

In 1951, after a succession of pastors and the resignation of Rev. J. A. Franklin, Rev. Milton A. Covington became pastor of the First Baptist Church of College Park. Here his wife, Effie, is pictured at the church pulpit. Below is church deacon Daniel Cameron, with his back to the camera. Over the next 47 years, under Covington's leadership, the church retired its debt, rebuilt the edifice, and greatly increased church membership. (Courtesy of First Baptist Church of College Park.)

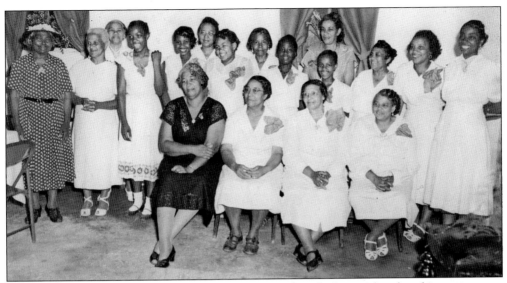

Ladies at First Baptist Church paused for this photograph during the church's anniversary celebration in the late 1950s. This event took place prior to the demolition and rebuilding of the church. The ladies are, from left to right, (first row) Mamie McCorkle, Mary Brooks, Alice Briscoe, and Maria Dory; (second row) Lucy Gordon, Mary Johnson Weems, Rose Cager Adams, Patricia Barber, June Jackson, Harriet Smith, Mary Rustin, unidentified, Jeanette Brooks, and Julia Pitts; (third row) Alice Branson, Mattie Cameron, Emma Conway, and Patty Hawkins. (Courtesy of Leonard Smith.)

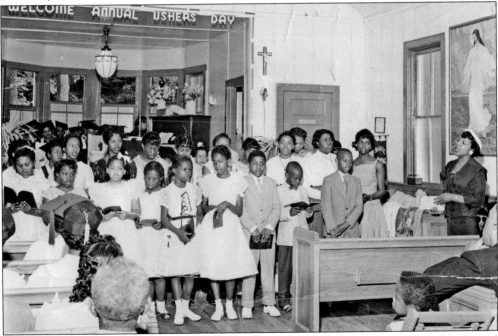

In 1956, Rev. Preston Britton and the congregation of Embry AME Church were the Annual Ushers' Day guests of Macedonia United Methodist Church in Odenton, Maryland. Britton delivered the sermon, and Embry's Junior Choir provided the music, under the direction of Dessie Randall Thomas (far right). (Courtesy of Pearl Lee Campbell and James Edwards III.)

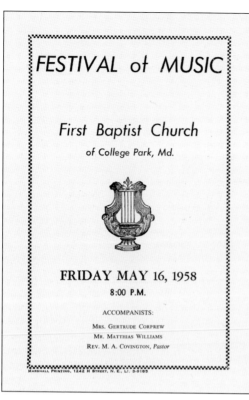

FESTIVAL of MUSIC

First Baptist Church
of College Park, Md.

FRIDAY MAY 16, 1958
8:00 P.M.

ACCOMPANISTS:

MRS. GERTRUDE CORPREW
MR. MATTHIAS WILLIAMS
REV. M. A. COVINGTON, Pastor

MARSHALL PRINTING, 1242 H STREET, N. E., LI. 3-9165

On Friday, May 16, 1958, a Festival of Music was sponsored by members of the First Baptist Church in support of the building fund. The program featured sacred music in both classical and gospel formats. The written program shows that performers were a mixture of Lakeland talent and friends of the sponsors. Performers that evening were soprano Lillian Staples and baritone gospel singer Robert Fields, along with pianists Janet Randall, Gertrude Walls Corprew, and singers James and Joseph Weems. (Courtesy of Diane Weems Ligon.)

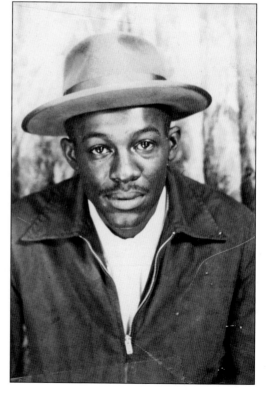

The churches, their organizations, and individual members often sponsored fund-raising activities. Robert Fields was a familiar figure in the musical events. Fields had an incredible voice that was the perfect instrument for gospel music. He is shown here around 1958, wearing a typical 1950s hat. (Courtesy of Leonard Smith.)

Due to the need for major renovations, Rev. Milton A. Covington and the congregation of the First Baptist Church decided to erect a new edifice. In 1959, the old church was demolished. Services were held at Lakeland Hall while the new church was erected by Pastor Covington (a mason), James Claiborne, Harold Pitts, and other dedicated parishioners. Members marched to their new church when it was completed in September 1962. (Courtesy of the Gross family.)

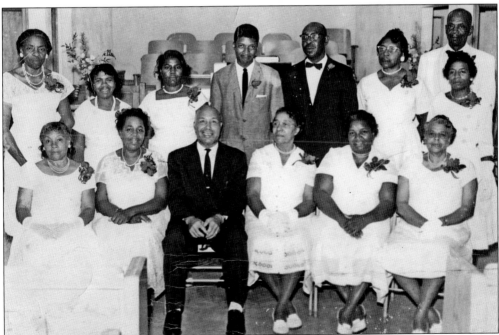

Rev. Milton Covington of the First Baptist Church is pictured here with parishioners on Women's Day in the 1960s. Seated from left to right are (first row) Elsie Moody, Mary Brooks Brewer, Reverend Covington, Mary Arthur Brooks, unidentified, and Maria Dory; (second row) Alberta Tolson, Viola Gross, Harriet Lee Morgan, Charles Adams, Currie Peele, Phoebe Fair, and Rosie Cager Adams; (third row) John Fair. (Courtesy of the Gross family.)

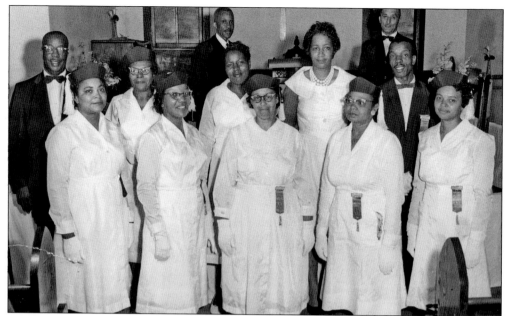

This 1960 photograph features the members of the Senior Usher Board at Embry AME Church. The ushers acted as official greeters and doorkeepers for church services. Pictured from left to right are (first row) Amy Brooks Hart, Dessie Randall Thomas, Martha Greenleaf Edwards, Helen Briscoe Brown, and Edith Brooks Taylor; (second row) Delarce Dory, Mary Brower, Agnes Scott, Lucille Giles Sharps, and Thomas A. Randall; (third row) Rev. Robert H. Baddy and Harry Braxton Sr. (Courtesy of Pearl Lee Campbell and James Edwards III.)

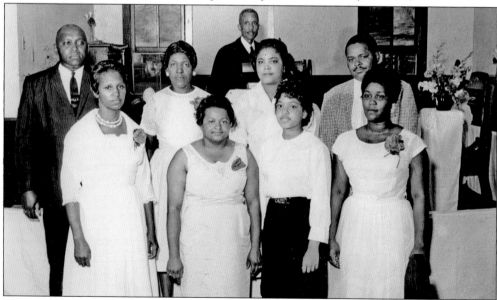

The Gospel Choir of Embry AME Church was organized by James Edwards Jr. in the early 1960s. Members of the choir, pictured from left to right, are (first row) Amy Potts, Marie Brown, organist Rosetta Brooks, and Ethel Wilson Brown; (second row) James Edwards Jr., Willa Mae Smith, Amy Brooks Hart, and Franklin Brown Jr. In the background is Rev. Robert H. Baddy. (Courtesy of Pearl Lee Campbell and James Edwards III.)

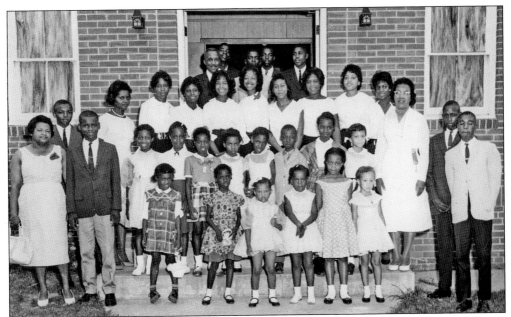

Dessie Randall Thomas served as Sunday school superintendent at Embry AME Church for 32 years. Through her dedicated teaching and fine example, she guided the religious education of generations of Lakeland's youth. Thomas is pictured here with the Sunday school students and staff in September 1962. She is in the center row, third from the right. The church pastor, Rev. Robert H. Baddy, is in the rear, far left. (Courtesy of Pearl Lee Campbell and James Edwards III.)

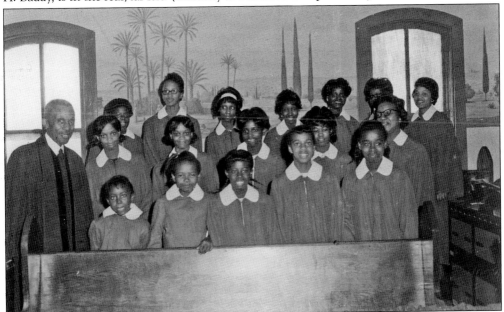

Embry AME Church's Junior Choir is shown here around 1965 with their pastor, Rev. Robert H. Baddy. The group served under the direction of Dessie Randall Thomas and was accompanied by Janet Randall on the piano. A member of the group recalls, "The recollection of those old hymns I learned as a child has helped me through many difficult times. Their lyrics have been a continual reminder of God's love and promises." (Courtesy of the Randall family.)

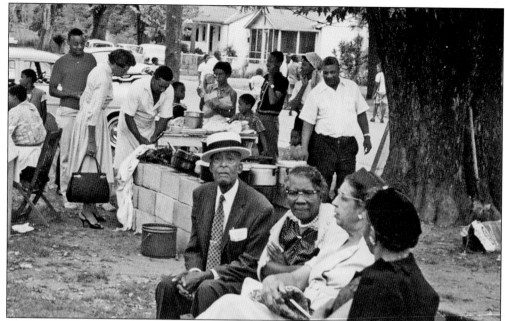

The churches of Lakeland have always been the true soul of the community. Gathering for dinner on the lawn of Embry AME Church has long been a summer tradition in Lakeland. In this 1962 photograph, William Sharps is shown wearing chef's whites preparing the day's meal. Seated in the foreground is Dora Robinson (third from the right), along with some friends, including Jacob Johnson, wearing the hat. (Courtesy of the Gross family.)

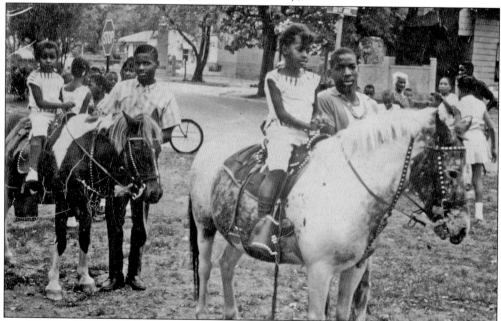

In addition to good, home-cooked food and the opportunity to visit with friends and family members during this Embry Church picnic on Labor Day in 1963 there was the added attraction of pony rides. On the left is Avis Matthews on a pony led by her uncle, Lester Gray; her sister Carol is riding a pony led by Ronald Brooks. (Courtesy of Jean Gray Matthews.)

Sunday school picnics were a summer highlight for Lakelanders. Everyone would pack a lunch and meet on the third Saturday in July at an amusement park or beach for a day of fun in the sun. The community's two churches regularly came together for the outing. In 1962, the Embry AME Sunday school outing took place at Carr's Beach in Annapolis, Maryland. From left to right are John Webster, Wilmer, Maxine and Delphine Gross, and Mary Weems Braxton. (Courtesy of the Gross family.)

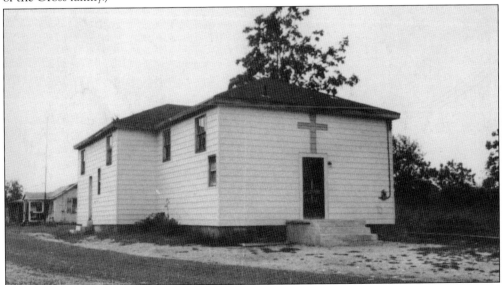

Built in 1926 as Lakeland Elementary School, this building in 1958 became home to Little New Zion Fire-Baptized Holiness Church of God of the Americas. A portion of the building contained an apartment, where the family of James and Anna Smith lived for years. Both the family and congregation were displaced with the coming of urban renewal. The congregation, now Greater New Zion Fire-Baptized Holiness Church of God of the Americas, is located in West Lanham, Maryland. (Courtesy of Thelma Lomax.)

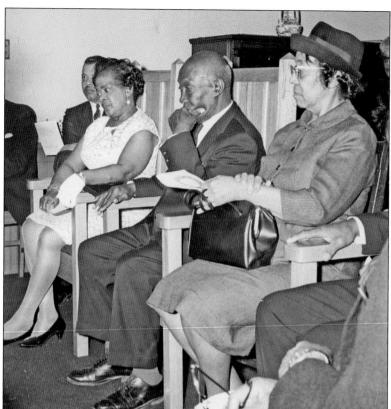

On December 29, 1967, Embry AME Church hosted a dinner honoring two stalwart members: church clerk Pauline Gray and church treasurer Arthur Brooks. The program featured testimonials and music, followed by a festive meal in the parish hall. Pictured from left to right are Pauline Gray, Arthur Brooks, and Brooks's wife, Mary. (Courtesy of the Gray family.)

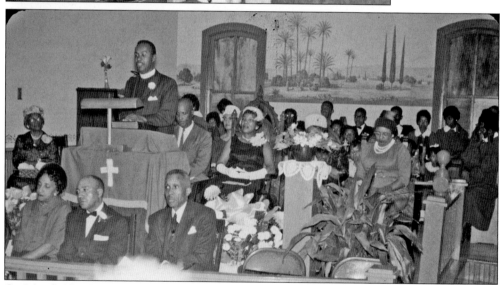

On March 28, 1969, an event was held to honor Rev. Robert H. Baddy's nine years as pastor of Embry AME Church. Baddy was born in the Hillsdale area of the District of Columbia and was ordained in 1935. A variety of church, community, and religious leaders made congratulatory remarks during the tribute, including former Lakeland School principal Edgar A. Smith; civic leader J. Chesley Mack; former Embry pastor Rev. James R. Gibson; and the Reverend Jeremiah Wright of Philadelphia, Pennsylvania. (Photograph © 2008 Joanne M. Braxton.)

First Baptist Church of College Park crowned Gwen Williams Miss First Baptist during a fund-raising pageant held at the church in the summer of 1970. Williams won by raising more money for the church than the other competitors. The Young People's Volunteer Choir provided music for the evening. (Courtesy of Thelma Lomax.)

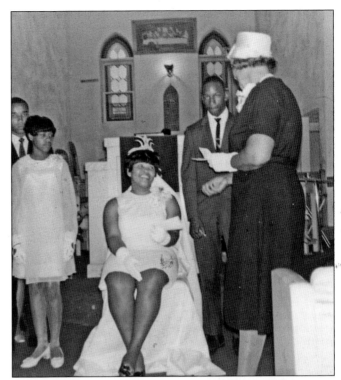

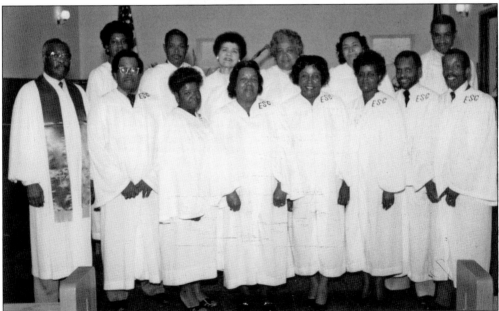

Rev. Dessie L. Carter (far left), pastor of Embry AME Church, is shown here around 1980 with members of the Embry Senior Choir. Pictured from left to right are (first row) Spencer Briscoe, Betty Thomas Green, Dessie Randall Thomas, Shirley Randall Anderson, Jean Gray Matthews, Lester Gray, and Thomas Randall; (second row) Janet Randall Gillens, Franklin Brown Jr., Florence Wethers Lee, Vera Johnson Matthews, Fannie Mae Randolph Douglas, and James Clemons. (Courtesy of Embry AME Church.)

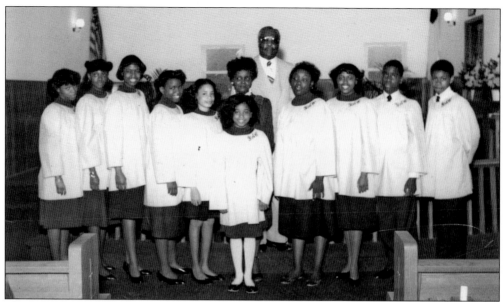

The Embry Youth Choir was organized in 1979 under the guidance of the pastor, Rev. Dessie L. Carter. Pictured are, from left to right, Talaya Boardley, Kimberly Gillens, Sharon Seldon, Linda Kim Lockerman, Monique Thomas, adviser Jean Gray Matthews, Reverend Carter, Lisa Gray, Kamille Gillens, Karon Seldon, Dean Matthews, and Paul Thomas. Members not shown are Lisa Carter, Barrett Matthews, Denise Penn, Nicole Thomas, and Pamela Tolson. (Courtesy of Embry AME Church.)

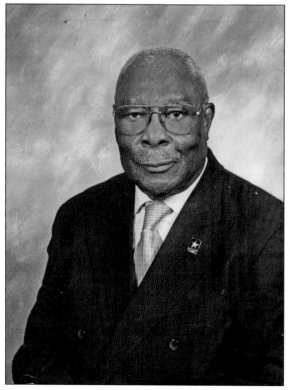

Rev. Dessie L. Carter, a native of Georgia, was pastor of Embry AME Church for 26 years. He joined the congregation in 1978 and led the church through its 100th anniversary in 2003. Along the way, he administered renovations to the physical structure and initiated programs and services that reached out to the entire community. Residents of the District of Columbia, Reverend Carter and his wife, Naomi, not only touched the lives of those who attended the church, but they also became familiar and trusted acquaintances with Lakelanders throughout the community. (Courtesy of Dessie L. Carter.)

Four

BY THEIR TOIL

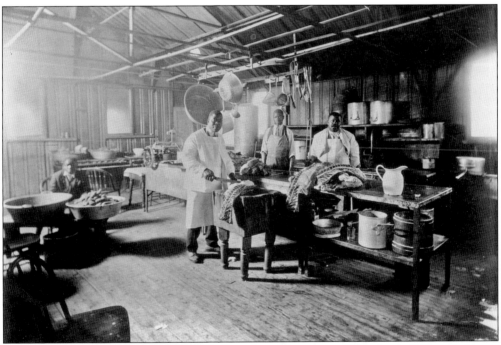

The kitchen of Maryland Agricultural College, later University of Maryland, College Park, was known as "Charlie Dory's health resort." Pictured from left to right are Bill Dory (behind the potatoes), Ferdinand Hughes, Spencer Dory, and Charlie Dory around 1912. The University of Maryland was a primary source of employment for many generations of Lakeland residents. (Courtesy of Special Collections, University of Maryland Libraries.)

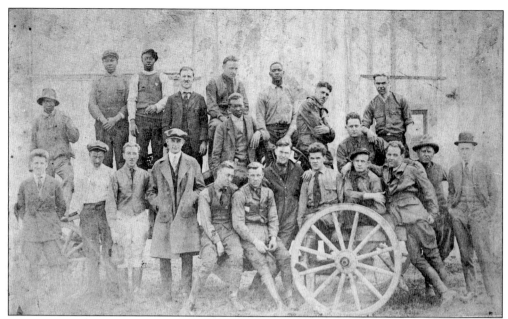

Airmail mechanics, couriers, pilots, and groundskeepers at the College Park Airfield's Airmail Station posed for this photograph. Lakelanders among the crew include Charles J. Johnson, Hans Hill, Paul Hill, George Brooks, and Bernie Brooks. The College Park Airport, located just beyond the boundary of Lakeland, is the world's oldest continuously operating airport. It was established in 1909 when Wilbur Wright came to the field to train military officers in flying the government's first airplane. (Courtesy of Thelma Lomax.)

Over the past 90 years, many Lakelanders have been employed at the Beltsville Agricultural Research Center, known to many locals as the government farm. In 1910, the U.S. Department of Agriculture purchased the 475-acre Walnut Grange plantation in nearby Beltsville and established a research facility. The Beltsville Agricultural Research Center would eventually expand to 1,662 acres and become the world's largest, most diversified agricultural research complex. (Courtesy of Leonard Smith.)

Benjamin Robert Hicks was employed for many years by the Baltimore and Ohio Railroad. He was a member of a crew that built, maintained, and repaired hundreds of miles of railroad track. In the photograph, he is the tall man in the middle wearing a dark jacket and a hat. Several of Lakeland's earliest African American settlers came to the community through their work on the railroad, including Benjamin Hicks, John C. Johnson, and Joseph Brooks. (Courtesy of Elizabeth Hicks Campbell Adams.)

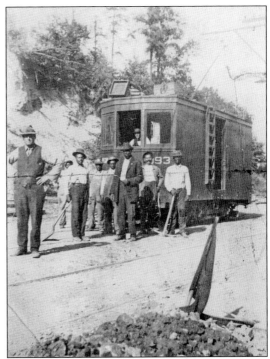

Between 1933 and 1937, the Department of Agriculture sponsored seven Civilian Conservation Corps (CCC) companies at the Beltsville Agricultural Research Center. The CCC was a New Deal program that employed young men in projects to preserve or enhance the nation's natural resources. In 1937, an African American CCC company was established at Beltsville. Later several former CCC apprentices, including James Claiborne Sr., Harold Pitts, and George Stewart, settled in Lakeland. (Courtesy of the National Archives at College Park, Maryland.)

Lakelander Arlene Davis is shown in this 1950 photograph dressed in early-American period clothing while carrying out her duties as a housekeeper at the Rossborough Inn. Built around 1803, the inn is located in College Park and was built to serve travelers on the road between the District of Columbia and Baltimore. The inn became part of the Maryland Agricultural College (now the University of Maryland) in 1858. It had served a variety of purposes until it was restored as an inn during the 1930s. Since 1954, the inn has been the home of the university's Faculty Club. (Courtesy of Elizabeth Hicks Campbell Adams.)

Many departments at the University of Maryland provided stable employment for Lakelanders. Pictured here are, from left to right, Pauline Gray and Etelka Johnson Lomax preparing meals in the kitchen at the Alpha Gamma Rho fraternity. Other Lakeland residents, including Saxoline Briscoe Campbell, Dorothy Tolson Holman, and Hazel Thomas, also were employed as cooks and kitchen-service staff for sorority and fraternity houses. (Courtesy of Thelma Lomax.)

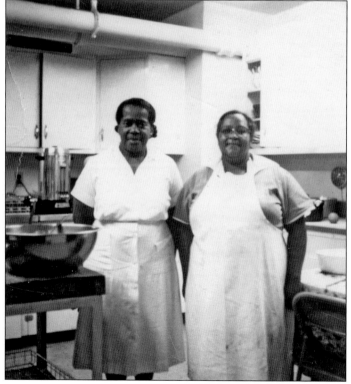

A member of the nationally known singing group the Ink Spots, Lakeland native Ernest Brown played guitar and contributed tenor vocals. On October 12, 1952, he was with the group when they appeared as guests on the iconic *Ed Sullivan Show*. Brown was one of the younger sons of early Lakeland resident Pleasant Brown. (Courtesy of Leonard Smith.)

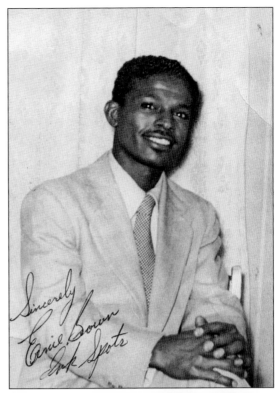

Members of College Park's Public Works crew were honored during a *c.* 1965 city council meeting. Mayor William Gullett (far right) is shown shaking hands with director of Engineering Services Caulder B. Morris. Lakelanders among the group include Chauncey Taylor Sr. (far left) and William Smith (next to him), as well as Paul Parker (third from the right). (Courtesy of the City of College Park, Maryland.)

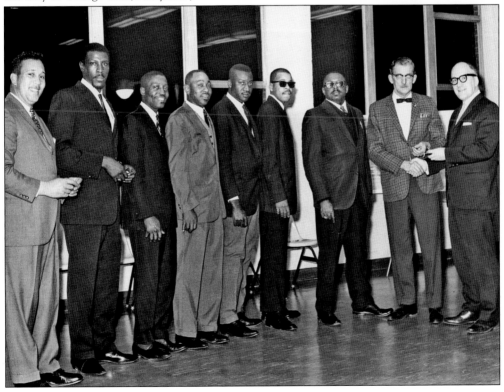

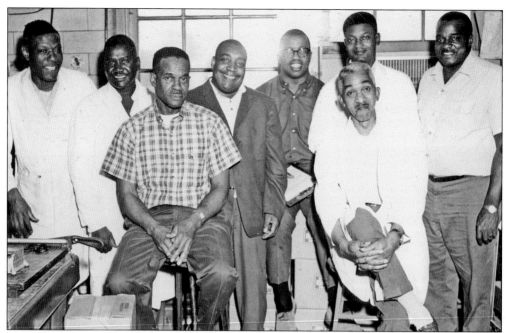

Several Lakelanders worked at the U.S. Bureau of Mines office located on the College Park campus of the University of Maryland. The office was responsible for the treatment of water in cooling and heating systems within federal installations. The staff received water samples, analyzed them, and then sent out the chemicals required for proper water treatment. Pictured from left to right are (first row) Morris Crump and Anderson Walls; (second row) Ike Thomas, Alfred Thomas, George Coates, Charles Smith, Charles Adams, and Charles Dory. (Courtesy of Thelma Lomax.)

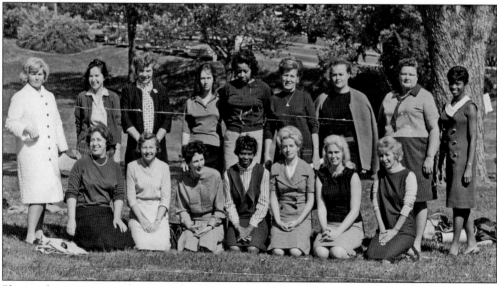

Physics department employees at the University of Maryland, College Park, assembled for this photograph in 1969. Among their number are Lakelanders Lucille Giles Sharps, Ethel Dory Lockerman, and Pearl Lee Campbell Edwards. These ladies worked as data analysts; it was their job to record the results of experiments done by doctoral students. The data they gathered were used as the basis for the student's theses. (Courtesy of Violetta Sharps Jones.)

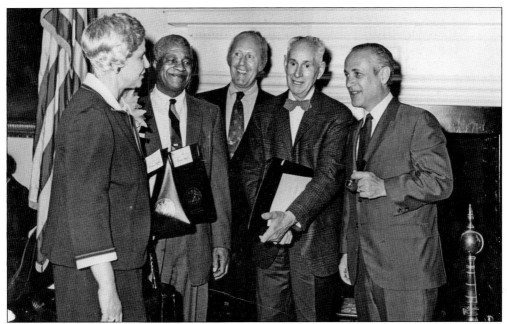

George Henry Gross (second from left) began his employment with the University of Maryland's Dining Services Department in 1923 and continued for 48 years. He was honored in 1968 for his 45 years of service along with other longtime University of Maryland employees. Maryland governor Marvin Mandel and Comptroller Louis L. Goldstein were on hand to congratulate the employees. (Courtesy of the Gross family.)

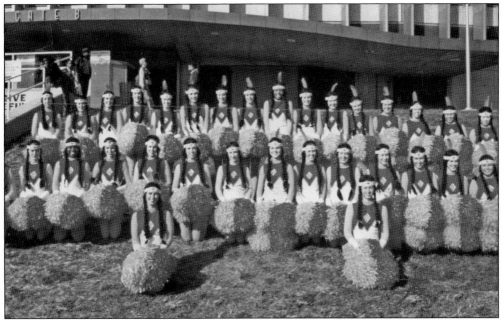

Clad in her hand-beaded, burgundy-and-gold team uniform, Sylvia Potts (first row, second from left) posed for this photograph with the other members of the Redskinettes, the official cheerleaders for professional football's Washington Redskins. In 1969, Potts became one of the first African American members of the cheering squad. (Courtesy of Sylvia Potts Cowell.)

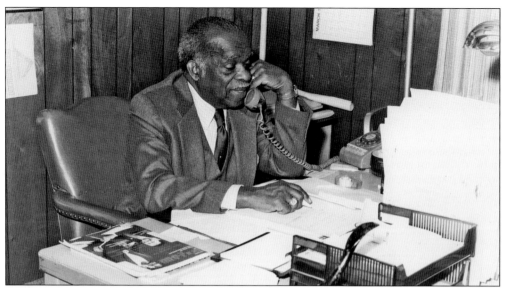

Robert Ridgley Gray had a stellar career as an educator and civic leader. Born in 1910 in Lakeland, he was the eighth child of James H. and Eliza E. Gray. In his unpublished memoir, Gray wrote: "In 1934, I had the honor of opening an eight-room school in Fairmount Heights. . . . At that time, this was the largest school in the state . . . built primarily for elementary education." Gray served his country during World War II. In January 1946, he returned to the school and served as principal there until his 1970 retirement. In 1964, he chaired a biracial committee studying the problems of integration in Prince George's County's public schools. From 1977 to 1989, Gray was mayor of Fairmount Heights, Maryland. In 2001, a new county elementary school was named for him. (Courtesy of the Gray family.)

Two generations of his family preceded Elwood H. Gross as employees at the University of Maryland. In earlier years, opportunities open to African Americans were limited. With the removal of racial barriers and his hard work, Gross rose from being an automobile mechanic's apprentice to the position of associate director of the Physical Plant. In 1988, Gross (second from left) was one of several recipients of the Associate Staff Award. (Courtesy of the Gross family.)

Willie Johnson worked as a food service manager at the University of Maryland and as a caterer. At the university, he formed friendships with many Lakelanders. Johnson said Lakeland reminded him of his home in Florida. Eventually, he bought a home and moved to the community, where he became a driving force in the hospitality ministry of Embry African Methodist Episcopal Church. The vegetables he grew in his garden and his Labor Day barbeques are fondly remembered by community members. (Courtesy of Carole Johnson.)

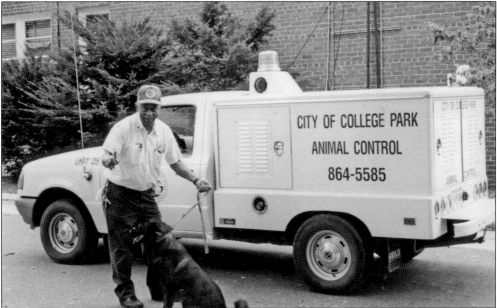

Harold Sampson began his long career as College Park's animal control officer in 1971. That year's October *Municipal Scene* newsletter reported, "His reputation is spreading fast. One dog from College Park Woods traveled through the rain and turned himself in at the Municipal Building this morning." That humorous report set the tone for Sampson's relationship with city residents. He was the most popular city staff member. (Courtesy of the City of College Park, Maryland.)

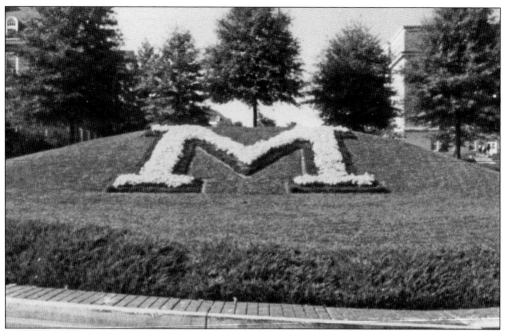

The Big "M" in the traffic circle on Campus Drive has been a landmark on the University of Maryland campus since the 1970s. Its recognition factor is second only to the University Chapel. James Adams of Lakeland was a member of the university's grounds crew for 37 years and was instrumental in the installation of this planting. (Courtesy of Elizabeth Hicks Campbell Adams.)

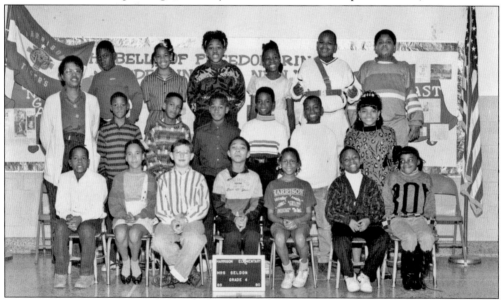

Barbara Brown Seldon (second row, far left) is among a long list of educators who were reared in Lakeland. Seldon graduated from Fairmont Heights High School in 1960; she earned a bachelor's degree from Bowie State University four years later. In 1983, she earned a master's degree in urban education from the University of the District of Columbia. For 30 years, Seldon taught at the District of Columbia's Harrison Elementary School. She is pictured with her 1990 fourth-grade class. (Courtesy of Barbara Brown Seldon.)

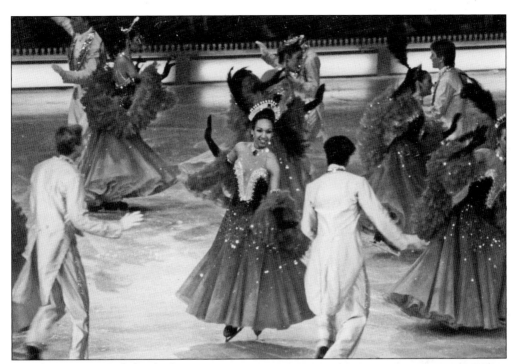

Fourth-generation Lakelander Lisa Hollomand started learning to skate at the Wells Rink in College Park. Her teacher recognized her talent, and her parents invested in years of private lessons. Between high school and college, from 1985 to 1987, Hollomand performed for two tours with Disney on Ice. This photograph was taken during a performance in 1985. After her tours, she taught skating at a number of area skating rinks. (Courtesy of Mary Day Hollomand.)

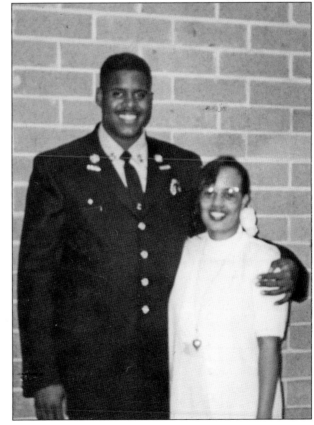

Willie C. Sellers Jr. grew up in Lakeland. He began his career as a Prince George's County firefighter in 1995. This photograph was taken on the day of his graduation; he is accompanied by his wife, Salena. Sellers was awarded a bronze medal for his "valorous actions on March 4, 1996," when he rescued several people from a burning building. (Courtesy of Willie Sellers Jr.)

Joanne Margaret Braxton, the daughter of Harry M. Braxton Sr. and Mary Ellen Weems Braxton, joined the faculty of the 300-year-old College of William and Mary in Williamsburg, Virginia, in 1980. With 29 years of service, she is the senior African American faculty member and the recipient of several awards for teaching, including the Outstanding Virginia Faculty Member Award. Braxton earned her undergraduate degree from Sarah Lawrence College and her master's and doctoral degrees from Yale University. She is a widely published scholar and poet. (Photograph © 2008 Joanne M. Braxton.)

Melonie Sharps Garrett grew up in Lakeland with her parents and three sisters. For the past 22 years, her career has flourished as a master certified coach and organizational development consultant. She is founder of ATG Coaching and Consulting, LLC, a personal and professional coaching and consulting business. Garrett has been a frequent speaker at local and national professional associations and universities. She still resides in Maryland with her husband, Ted, and has two children, Adia and Theo, for whom her business is named. (Courtesy of Melonie Garrett.)

Five

SERVICE TO THE NATION

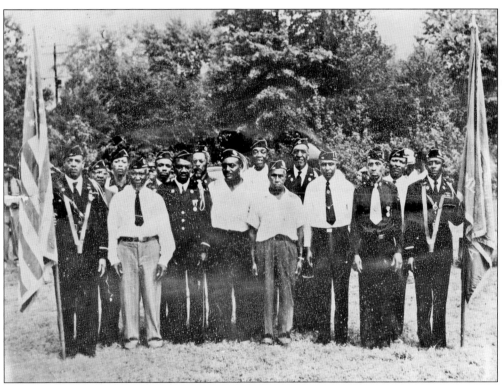

Lakeland's American Legion Post was named for John Henry Seaburn, a North Brentwood resident who served and died overseas during World War I. The post was active from 1940 until the 1970s. With the coming of urban renewal efforts, their meeting place, Lakeland Hall, was demolished. The post disbanded, and members joined other area posts. Members of Lakeland's post are pictured here around 1960. (Courtesy of Magdalene Johnson.)

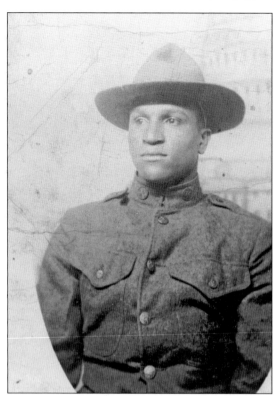

Joseph Johnson, son of John Calvary Johnson, served as a member of the U.S. Army during World War I. He was one of the first Lakelanders in service to his country. From the founding of the community, Lakeland residents worked individually and collectively to serve and defend their community and nation. (Courtesy of the First Baptist Church of College Park.)

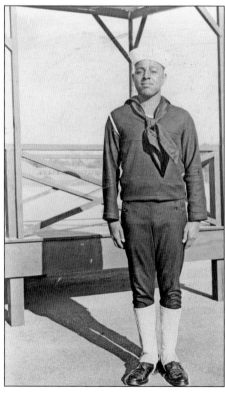

Dervey A. Lomax joined the U.S. Navy during World War II and served in the Pacific, including Pearl Harbor, Guadalcanal, and Okinawa. He returned from military service having gained training in electronics. In 1948, Lomax was hired by the Department of the Navy. Ultimately, he rose to the position of supervisory electronic technician with the Naval Electronic Systems Security Engineering Center. Lomax retired after more than 30 years of federal service. (Courtesy of Thelma Lomax.)

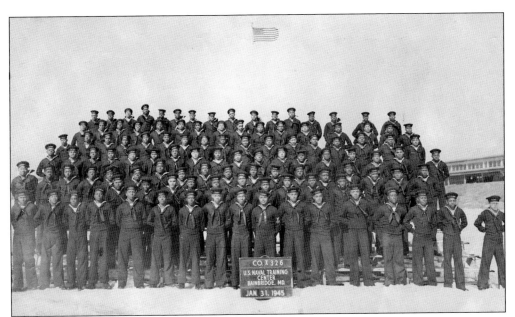

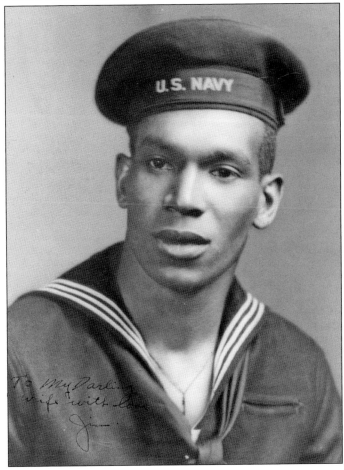

James Weems (third row, second from right) was inducted into the U.S. Navy in 1944 and went for training at the U.S. Naval Training Center in Bainbridge, Maryland. When the United States entered World War II, the navy's African American sailors had for decades been limited to serving as mess attendants. However, the wartime pressures of a manpower shortage and the willingness of thousands of African Americans to serve, plus political pressure, forced important changes. Though the navy remained racially segregated in training and in most service units, in 1942, the enlisted ranks were opened to all qualified personnel. Weems sent the photograph at right to his wife, Mary, while he was serving aboard a ship in the Pacific theater. (Both courtesy of Diane Weems Ligon.)

Charles Carroll served in the U.S. Navy during World War II. He was called up for service after having settled in Lakeland with his wife, Julia Mack Carroll. Carroll was a teacher in the District of Columbia public school system and later a draftsman with the Department of the Navy. After retiring from federal service, he was employed by the University of Maryland as its first African American personnel officer. He retired from that position after 10 years. From 1973 to 1979, he represented Lakeland on the College Park City Council. (Courtesy of Dorothea Allen Houston.)

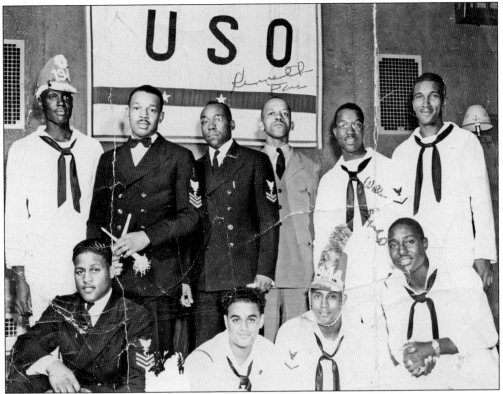

During their 1944 New Year's celebration, complements of the United Service Organizations, Willie Hunter Randall of Lakeland and Kenneth Davis of North Brentwood paused for this photograph. Randall served in the U.S. Navy from October 1943 to January 1949. He traveled to his duty station by sea. His daughter was named Via, meaning "by way of," in honor of that voyage. Family members report that he had many humorous stories about his service. One niece, Pamela Randall Boardley, recalled, "He made it seem as though he single-handedly won the war." (Courtesy of the Randall family.)

In 1942, Edward Lee Tyner was home on leave from the U.S. Navy. Here he celebrates with his wife, Evelyn Giles Tyner, next to him on his right, and friends. They are, from left to right, Eunice Johnson, the Tyners, Vera Johnson Matthews, Mary Weems, Mary Walls Weems, and unidentified. (Courtesy of Diane Weems Ligon.)

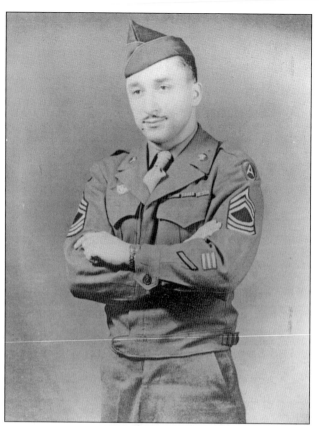

M. Sgt. Harry M. Braxton Sr. was assigned to the Quartermaster Corps during World War II and was a driver with the Red Ball Express. When army general George S. Patton made a rapid advance across France in 1944, he stretched his supply line to near collapse. Supply trucks rolled continuously 20 hours a day, seven days a week for 82 days across France and into Germany, often facing attack from the ground and the air. Nearly 75 percent of Red Ball Express drivers, like Braxton, were African Americans. Later Braxton served with Graves Registration and worked to give Holocaust victims the respect they deserved in death by providing them with proper burial. Years later, when he reflected on his service, he expressed great admiration for General Patton and was proud to have served. (Both courtesy of the Gross family.)

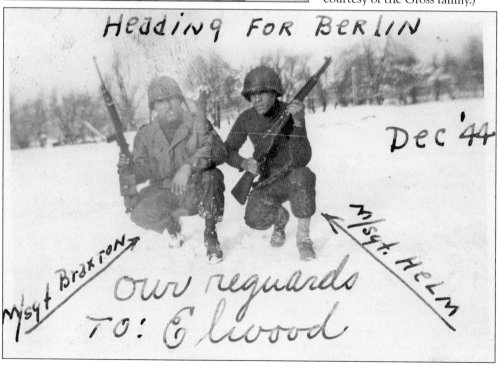

Heading For Berlin

Dec '44

M/sgt Braxton

M/sgt. Helm

our reguards to: Elwood

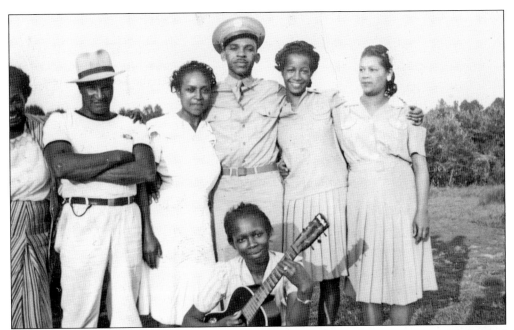

At home on leave from the U.S. Army during World War II in 1942, George "Pete" Walls is surrounded by friends. From left to right are Mary Jane Giles Fields, Amos Guss, Gertrude Davis, Pete Walls, Lucille Giles, Gertrude Brooks, and Evelyn Giles Tyner, playing the guitar. (Courtesy of Mary Hamlett Harding.)

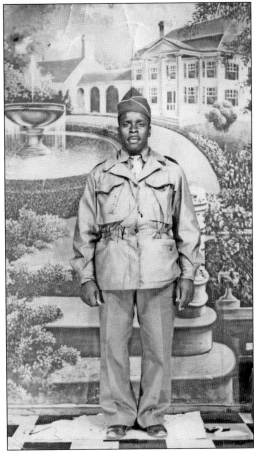

The youngest of nine children, Clarence A. Gray Sr. was stationed at Fort Bragg, North Carolina, in September 1945, at the same time his brother Ridgley was stationed overseas. Returning to his base after a visit home to Lakeland for the Labor Day weekend, Private Gray wrote to his brother, "The war is over, and if you are like me, you are glad knowing everybody will be going home shortly. I have more training to go. . . . I don't know where then. I hope home." Clarence and Christine Gray reared 13 children in Lakeland. (Courtesy of the Gray family.)

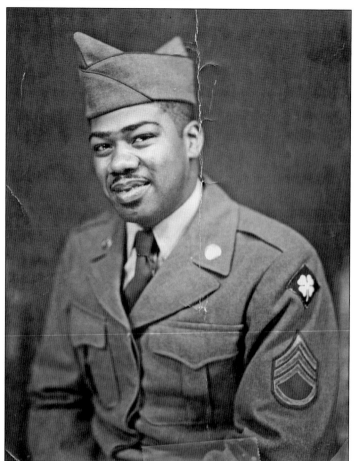

Leonard Smith moved as a young man from Beltsville, Maryland, to Lakeland. He graduated from Lakeland High School and attended Maryland State College. Smith entered the U.S. Army in 1950. He is shown below at a master gunner's course in Fort Bliss, Texas. Smith rose to the rank of staff sergeant. Upon returning to Lakeland, he became a leader in the community's American Legion Post. In 1972, Smith was elected American Legion commander for Prince George's County, Maryland, by delegates from the region's 19 posts, 16 of which were majority white. Smith was the first African American to hold that position. As county commander, he led a membership of 7,000. (Both courtesy of Leonard Smith.)

Korean War serviceman Louis Raymond Gray Jr., nicknamed "Manny," was the son of Louis Gray and Florence Wethers Gray. He spent much of his Lakeland youth at the Navahoe Street home of his aunt Gertrude Corprew and with his cousins at their grandfather James H. Gray's home, near the Baltimore and Ohio Railroad. He attended Lakeland schools until 1950, when his class was among the first to attend Fairmont Heights Junior-Senior High School. (Courtesy of the Gray family.)

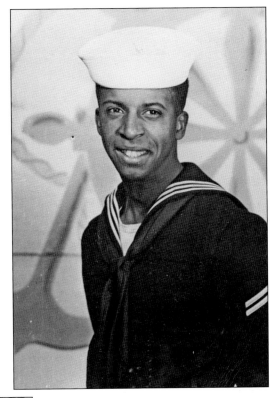

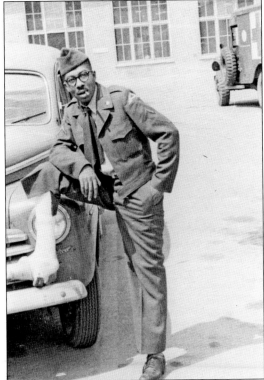

Elwood Harrison Gross, the son of George Henry and Agnes Gross, was born in his parents' home on Cloud Avenue in Lakeland. He attended elementary and junior high school in the community. After studying at St. Paul's College in Lawrenceville, Virginia, he was drafted in 1957. A trained automobile mechanic, Gross served with the U.S. Seventh Army's 569th Ordnance Company in Germany as a truck (tank) mechanic. (Courtesy of the Gross family.)

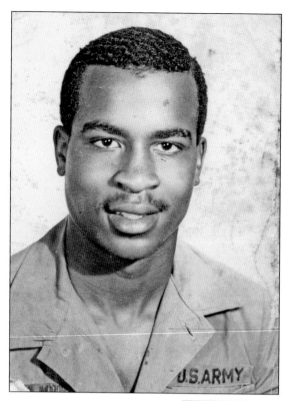

Maseo D. Campbell, the son of Maseo and Elizabeth Hicks Campbell, grew up with his brother and four sisters on Navahoe Street. After graduation from Northwestern High School, he was inducted into the U.S. Army. Campbell served in Vietnam, with posts in Long Ben and later Diel Tang, where he was assigned the task of transporting jet fuel from Phu Vinh to the Mekong Delta, surviving many attacks along the Ho Chi Minh Trail. Campbell was discharged with honors on August 1, 1969. (Courtesy of Elizabeth Hicks Campbell Adams.)

Sgt. Leroy W. Pitts, the son of Harold and Julia Pitts, was born in 1941 at Freedman's Hospital in the District of Columbia. He grew up in Lakeland and was educated in Lakeland schools through junior high school. In 1964, he married Virginia Pumphrey. They had a daughter, and he helped raise two stepchildren. In 1966, Pitts was inducted into the U.S. Army and served in Vietnam. (Courtesy of Julia Pitts.)

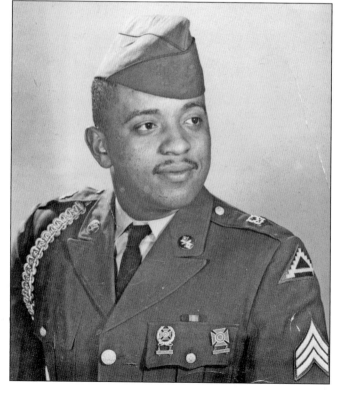

Cpl. Thomas Reynold Randall, lovingly known as "Bubby," joined the U.S. Marine Corps in December 1969. After completing infantry training, he was stationed at Quantico, Virginia, and later at Camp Courtney in Okinawa, Japan. After completing his term of service, Randall earned a Bachelor of Science degree in business administration at Morgan State University in Baltimore, Maryland. (Courtesy of the Randall family.)

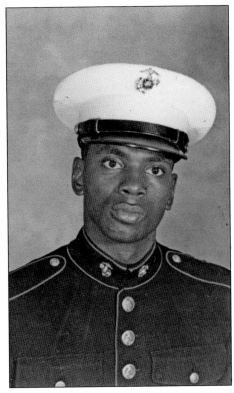

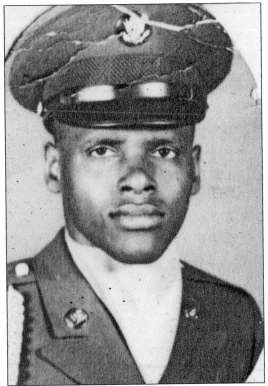

Lester Maynard Gray, the ninth child of Clarence and Christine Conley Gray, joined the U.S. Army after his 1966 graduation from Fairmont Heights High School. He served honorably as a communications technician during the Vietnam War. Following his discharge, he successfully transferred his technical skills to a career with Western Union. While at Fairmont Heights, Gray's standout baritone voice won him a featured soloist spot with the school chorus. As an adult, he rejoined Embry AME Church and continued his love of singing as a member of the Senior Choir. (Courtesy of the Gray family.)

Sfc. Harry M. Braxton Jr. grew up in Lakeland. After attending Bowie State College in Maryland, he enlisted in the U.S. Army and completed a career-spanning 22 years. Braxton served in Iraq during the Persian Gulf War, where his contributions earned him a Bronze Star Medal for "exceptionally meritorious service." At the end of his career, Braxton was awarded the Meritorious Service Medal. In this 1990 photograph, Braxton appears with his wife, S.Sgt. Loretta Ann Braxton, just months before their wartime deployment to Iraq. (Courtesy of Harry M. Braxton Jr.)

Today young Lakelanders continue to dedicate themselves to lives of service. First Lt. Charles Benjamin Houston participated in the Reserve Officers Training Corps (ROTC) at the Georgia Institute of Technology and Georgia State University. In 2006, he graduated from Morehouse College. Houston was promoted to first lieutenant in November 2007. In late 2008, he completed a 15-month tour of service in Iraq as a military police officer. (Courtesy of Dorothea Allen Houston.)

Six

SERVICE TO THE COMMUNITY

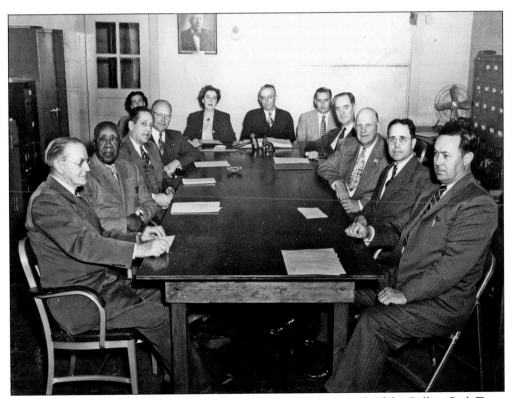

J. Chesley Mack is seated second from the left in this 1957 photograph of the College Park Town Council. He served as a member of that legislative body from 1945 until 1957. Mack was one of the first in Lakeland to complete a course of higher education. He was an influential local leader, a successful businessman, and a chef employed by the University of Maryland. (Courtesy of Dorothea Allen Houston.)

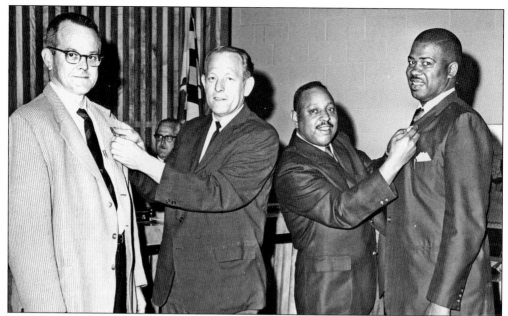

In 1965, Leonard Smith was elected to the College Park City Council. In this photograph, outgoing councilman Dervey Lomax, second from the right, is shown affixing Smith's council pin. In addition to being a civic leader, Smith was a contractor, property developer, and entrepreneur. He served as a member of the College Park City Council until 1967. (Courtesy of Thelma Lomax.)

Members of the Lakeland community have always been active in civic affairs. For many years, the City of College Park has held annual events honoring those who serve on its various citizen committees and boards. In 1969, this event took the form of a dinner where certificates were presented to each honoree. Featured here is Mayor William Gullett (far right) with Lakeland residents, from left to right, Hattie Lewis, Mary Weems Braxton, and George Brooks Jr. (Courtesy of the City of College Park, Maryland.)

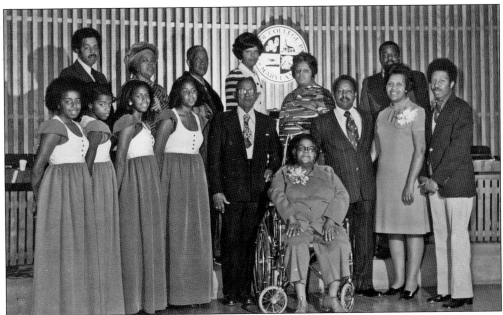

After serving several terms as a member of the College Park City Council, Dervey Lomax was elected mayor of College Park in 1973. The event marked a milestone for the citizens of Lakeland, as he was their first native son and the only person of color to have been elected to that high office. His installation was an evening of celebration. Present for the ceremonies (above) were the following, from left to right: (seated) Etelka Lomax, the mother of Mayor Lomax; (first row) four members of the Lomax Sisters singing group; Charles Lomax, the father of the mayor; Mayor Lomax; his wife, Thelma; and their son Gregory; (second row) William Lomax, Vera and Phillip Matthews, Valarie Smith, Delores Dotson, and Charles Dory. During his many years on the city council, Mayor Lomax worked untiringly to better his community. Below, he is shown in the rumble seat of an antique Ford as a participant in the 1974 College Park Boys and Girls Club parade. Lomax served a total of 27 years on the College Park City Council. (Both courtesy of Thelma Lomax.)

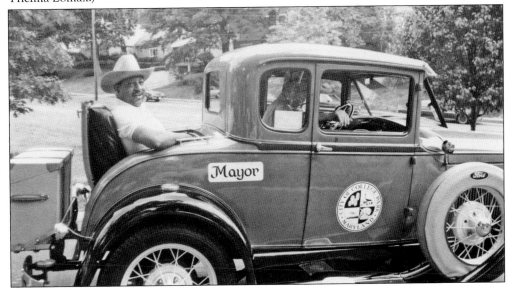

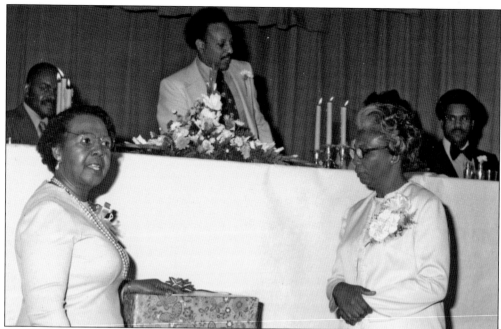

The Lakeland Civic Association honored Hattie Sandidge with a gala banquet on June 7, 1975. Sandidge was a leader in the Lakeland community for many years. She served as president of the Lakeland Civic Association and as a deaconess of First Baptist Church. With the implementation of the Lakeland Urban Renewal Project, the Sandidge family home was slated for demolition. Sandidge, her husband, Enoch, and their family moved out of the community. Below, the Sandidge family gathered during the 1975 banquet. From left to right are (first row) Marcus Waddy and Trina Thompson; (second row) Gela Portee, Jennie Thompson, Connie Sandidge, Hattie Sandidge, Enoch Sandidge, Wiley Portee, and Myra Wood; (third row) Jean Sandidge, Cheryl Thompson, Bonita Waddy, Ronald Brooks, Gela Sandidge Brooks, and Danny Thompson. (Both courtesy of Thelma Lomax.)

Members of the 1975 Banquet Planning Committee honoring civic leader Hattie Sandidge included many steadfast members of the Lakeland Civic Association and longtime Lakeland residents. They are, from left to right, (first row) Lois Copeland, Mary Lyons, Mary Weems Braxton, and Julia Mack Carroll; (second row) Harry Braxton Sr., Thelma Lomax, Julia Smith Pitts, and James Claiborne Sr. Pictured at right at the banquet are city council member Charles Carroll and his wife, Julia Mack Carroll. The Lakeland Civic Association has been active continuously since the 1930s. George Brooks Sr. served as president for 25 years. He was succeeded by James Claiborne, Leonard Smith, Elwood Gross, Julia Carroll, Hattie Sandidge, Dervey Lomax, James Weems, James Adams, Fannie Featherstone, Karen Roberts, Maxine Gross, Diane Weems Ligon, and Monroe Dennis. The Lakeland Civic Association continues to work to preserve and improve Lakeland as a residential community and to protect its unique heritage. (Above courtesy of Julia Pitts; right courtesy of Thelma Lomax.)

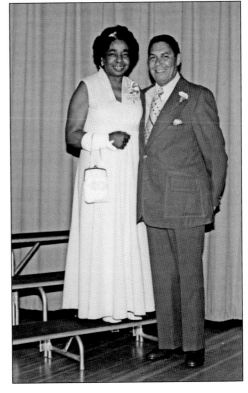

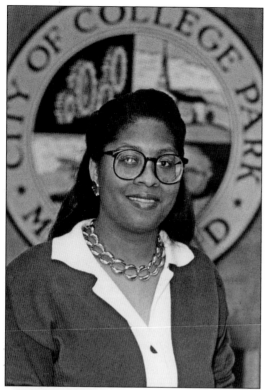

A fourth-generation Lakelander and former Lakeland Civic Association president, Maxine Gross was elected to the College Park City Council in 1989 and served until 1997. Gross graduated from the University of Maryland. Her graduation meant a great deal to her family, as family members for three generations had worked for the university but had been barred from attending because of segregation. (Courtesy of the Gross family.)

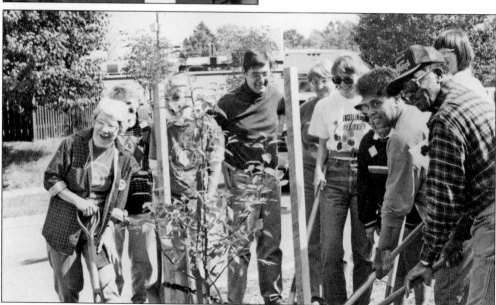

Members of the College Park Committee for a Better Environment, including the chairwoman, Amelia Murdoch (far left), and Lakelanders Wilmer Gross and James Adams (far right), planted trees at an Earth Day event. The Committee for a Better Environment is made up of College Park citizens with an interest in improving the environment and quality of life in the city. The committee promotes, sponsors, and provides support for local environmental projects and activities. (Courtesy of the Gross family.)

Seven

COMMUNITY LIFE

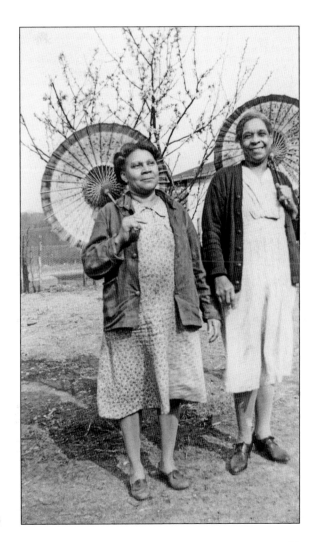

Ella Falls (left) and Maggie Brooks (right), two of Lakeland's early residents, were neighbors residing on the east side of Lakeland for more than 50 years. Here they are shown enjoying the lakeside view while taking a stroll with their parasols. (Courtesy of Mary Hamlett Harding.)

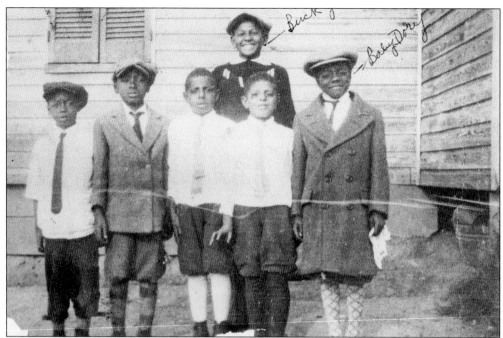

Around 1935, these boys were photographed in their Sunday best, which included knickerbockers. "They're wearing knockers," commented Leonard Smith, who grew up in the era, upon seeing this photograph. "You were dressed up then." In the rear is Henry "Buck" Johnson, and in the first row, far right, is Charles Dory. Dory as a teen was a star basketball player for Lakeland High School and went on to work as a cook for the railroad. He was also a deacon of the First Baptist Church of College Park. (Courtesy of the Randall family.)

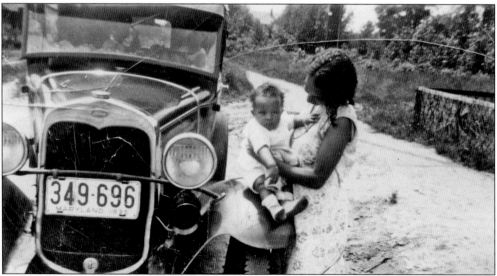

Mazie Davis Adams admires her eight-month-old son, Elmore, on the fender of a Ford automobile with a 1935 license plate. A native of Bladensburg, Maryland, she married Warner Adams of Lakeland. In 1931, the couple moved with his mother to a home on Navahoe Street and lived there until the house was destroyed by fire in 1964. In addition to their son, they had two daughters. (Courtesy of Diane Weems Ligon.)

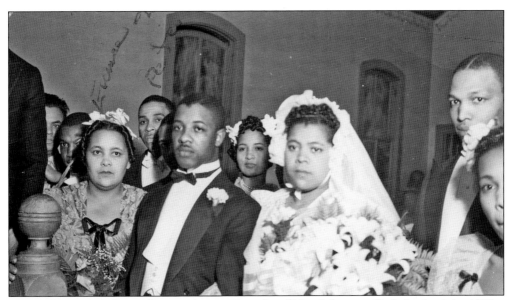

The wedding of Phillip "Billy" Matthews of Laurel and Vera Johnson of Lakeland in May 1939 is recalled by guests more than 60 years later as one of the grandest events the community had seen. One guest reflected, "Everyone was there. . . . People had started getting good federal jobs and could, and did, celebrate." Members of the wedding party are, from left to right, Eunice Johnson; George Walls, groom; Gertrude Walls Corprew, bride; Benjamin Briscoe, Jr. and Pearl Brooks Briscoe. (Courtesy of the Randall family.)

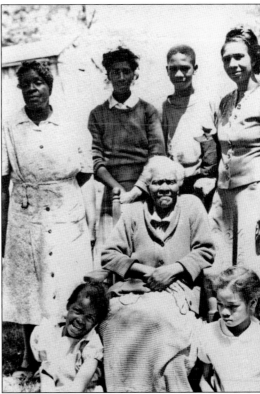

As a young woman, Margaret Gross Gray moved to New York City and married; yet she still maintained ties to Lakeland. Her visits were frequent and her children and grandchildren came for long holidays "in the country." One visit with Gray's grandmother, Harriet Hughes of Lakeland Road (seated, center), is captured here around 1942. From left to right are (seated) Amelia Wilson and Jean Gray; (standing) Beatrice Hughes Thomas, Cora Gross, George Gray, and Margaret Gross Gray. (Courtesy of the Gross family.)

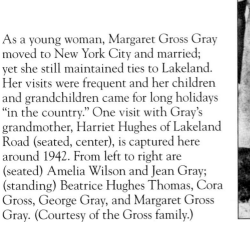

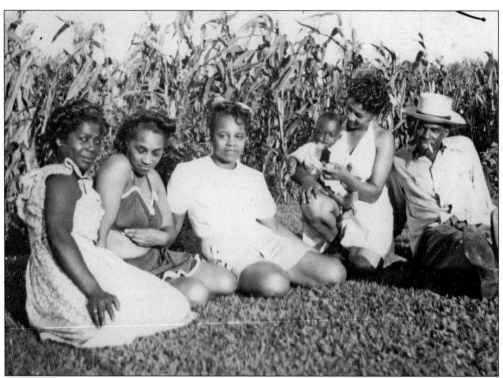

In the summer of 1944, neighbors enjoyed a day relaxing in the rural countryside of Lakeland. In this photograph, longtime neighbors proudly show off their newest neighbor, infant James "Little Jimmy" Edwards III. Sitting in the cornfield from left to right are Lola Giles, Viola Brooks, Cecelia Brooks, Gertrude Brooks, and Morris Crump. (Courtesy of Mary Hamlett Harding.)

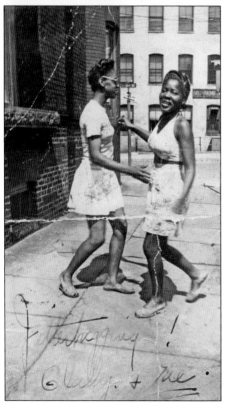

Lakeland girls Ruby Briscoe (left) and Gladys Conley (right) jitterbug on a Newark, New Jersey, street in the 1940s. They were like many others who migrated to industrial cities for the plentiful jobs that were available during World War II. Briscoe, later Ruby Tynes, made New Jersey her home. Conley returned to Maryland and was a schoolteacher in St. Mary's County. Both retained lifelong ties to their family and friends in Lakeland. (Courtesy of the Gray family.)

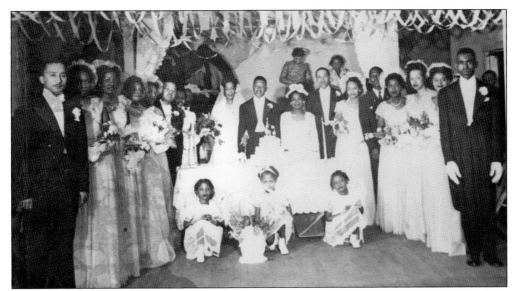

William Sharps of North Brentwood and Lucille Giles of Lakeland were married March 15, 1945, at Embry AME Church. Rev. W. E. Mosley presided. The formal wedding reception was held at Lakeland Hall. Members of the wedding party included, from left to right, Harry Braxton Sr., Evelyn Giles, Omega Giles, Blanche Sharps, Vera Matthews, Wallace Sharps, Mary Braxton, the bride, the groom, Lola Giles, George Walls, Cecilia Brooks, Robert Fields, Shirley Randall, Margaret Sharps, Cozette Johnson, and James Weems. The flower girls are, from left to right, Patricia Barber, Shirley Tyner, and Edna Tyner. (Courtesy of the Sharps family.)

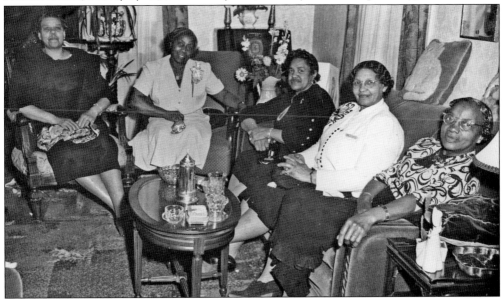

Teas were a favorite social activity for the ladies of Lakeland. These events were sometimes held in the churches as fund-raising activities, but most often, they were social occasions in homes. Each hostess took great pride in her ability to set a fine table. Pictured here is one such gathering at the home of George Henry and Agnes Gross. Their guests are, from left to right, Maria Lomax Dory, Fannie Williams, Annabelle Stroud, Ellen Lomax Briscoe, and Ellen Randall Gray. (Courtesy of Jean Gray Matthews.)

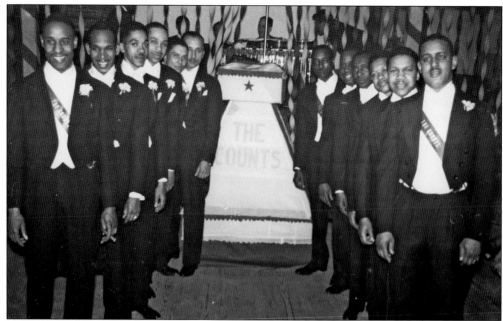

In the 1940s and 1950s, much of the organized entertainment in Lakeland was provided by social clubs. These clubs met monthly at the homes of members. Dinners were part of the gathering and provided the host an opportunity to showcase both cooking ability and tableware. The Duchesses and the Counts social clubs sponsored an annual formal dance at Lakeland Hall and sometimes posed for professional photographs. The Counts appear above in formal tails and white gloves. The gentlemen are, from left to right (left row) Gasson Bradford Sr., James Weems, Anderson Walls, George Walls, Charles Carroll, and Harry Braxton Sr.; (right row) Mack Allen, John Webster, William Sharps, Aubrey Corprew, Chesley Mack, and Ashby Tolson. The Duchesses social club was photographed below during their 1947 evening social event. They are, from left to right, Mary Walls Weems, Cecilia Brooks Stewart, Gertrude Walls Corprew, Evelyn Giles Tyner, Florence Wethers, Martha Edwards, Pearl Brooks Briscoe, and Eliza Gray. (Both courtesy of Diane Weems Ligon.)

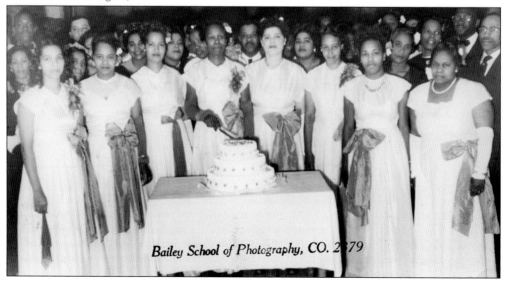

Bailey School of Photography, CO. 2379

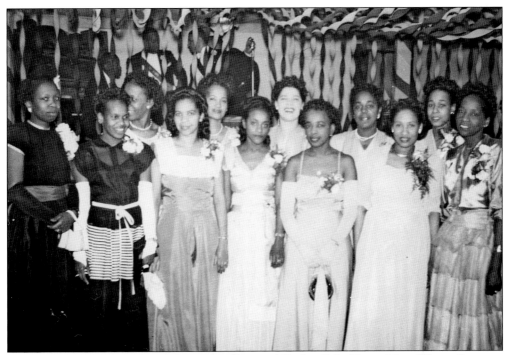

The Counts' escorts are, from left to right, (first row) Evelyn Giles Tyner, Mary Weems Braxton, Mary Walls Weems, Bernice Lancaster Walls, Julia Mack Carroll, Mary Douglas Tolson, and Dorothy Mack Allen; (second row) Pearl Brooks Briscoe, Gertrude Walls Corprew, Florence Wethers, Mary Brooks Brewer, and Elizabeth Mack. (Courtesy of Diane Weems Ligon.)

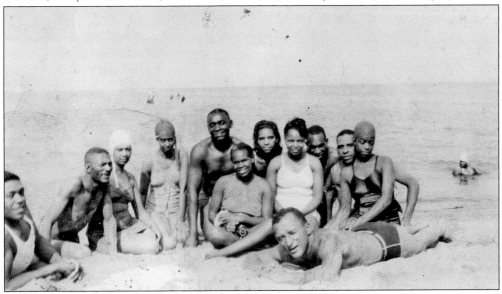

Members of the "greatest generation" enjoy a day at Carr's Beach in Annapolis, Maryland, during the 1940s. Carr's Beach was a summertime retreat for African Americans from its opening in 1929 until the late 1960s. As part of the famous "Chitlin Circuit," it attracted some of the era's greatest African American musical talent. The Chesapeake beaches were not racially integrated until the 1950s. (Courtesy of Pearl Lee Campbell and James Edwards III.)

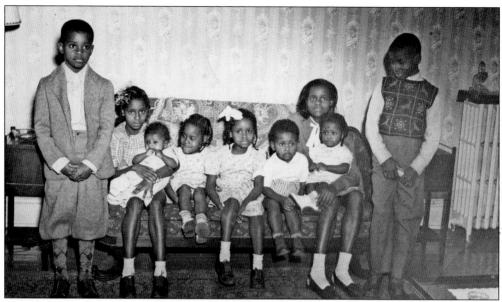

The children of Clarence Gray Sr. and Christine Conley Gray gather at the home of their grandfather James H. Gray in 1948. Through the early 1970s, the home was the center of extended-family festivities, including Christmas dinners and Fourth of July fireworks. Pictured are, from left to right, Barnett, Mildred holding Lester, Linda, DeWana, Myron, Jean holding Cheryl, and Clarence Jr. By 1954, this branch of the Gray family tree also included Tanya, Zandra, James, and Benay. (Courtesy of the Gray family.)

In 1947, James Henry Gray sat for this formal photograph with, from left to right, his eldest son, William H. McKinley Gray ("Will"); grandson William H. McKinley Gray II; and great-grandson William H. McKinley Gray III ("Butch"). James H. Gray died in 1957. His family maintained the home on Pierce Street for two more decades. Will, following in his father's path, was a successful interior painter and paperhanger in the District of Columbia. A World War I veteran, he is buried in Arlington National Cemetery. McKinley owned PauMac Photographers in the District of Columbia and built an extensive archive of images. Butch died in childhood following surgery. (Courtesy of the Gray family.)

William and Lucille Sharps, at their home in Lakeland with Pamela, age two, welcomed baby daughter Violetta to the family in September 1948. Daughters Melonie and Joy joined the family in 1955 and 1959. Their home was the family residence for four generations until it was razed to make way for urban renewal. The family relocated to Lanham, Maryland, in February 1975. (Courtesy of Violetta Sharps Jones.)

The Christmas season served as portrait-taking time for Diane Weems and her younger brother, Donald Weems (Kuwasi Balagoon). This picture was taken around 1950 in the living room of the family home on Navahoe Street. (Courtesy of Diane Weems Ligon.)

George Henry and Agnes Harrison Gross were married in a quiet ceremony at the home of her sister Ira in Baltimore, Maryland. The couple chose to make a festive occasion of their 25th wedding anniversary. Family and friends were invited to the Gross residence on Cloud Avenue on April 8, 1950, for a reception. Pictured above from left to right are George Henry Gross, Agnes Harrison Gross, and their son, Elwood Harrison Gross. Below, the Grosses view their anniversary gifts. (Both courtesy of the Gross family.)

Both Thomas Albert Randall and Agnes Serena Ross grew up in Lakeland. They were married on December 24, 1941, and had four children at the time of this 1949 photograph. They are twins Janet (far right) and Jacqueline (far left), Thomas, and Pamela. The youngest child, George, was born in 1953. (Courtesy of the Randall family.)

George Elliott Randall was six months old in 1954, when this photograph was taken. "What a time we had getting him ready for this picture," his mother remembered. "His sister Janet walked him up and down the street and fed him plenty of Sugar Babies." This photograph of young Randall was taken by Verdell Nesbitt, Lakeland's own photographer. (Courtesy of the Randall family.)

Baseball was an important summer pastime among the African American communities in Prince George's County. Most of the communities had their own teams, which played each other. The baseball season was capped with a day of games and picnicking in Laurel, Maryland, to commemorate the signing of the Emancipation Proclamation. Norwood Walls was one of the young pitchers who participated in these events during the 1940s and 1950s. He is shown here around 1947. (Courtesy of Diane Weems Ligon.)

James Adams (left) and Maseo Campbell (right), like many young family men of Lakeland, were members of the community's baseball team. These two gentlemen, shown in the late 1950s, were both teammates and cousins. The popularity of the games diminished in the 1970s, and Lakeland stopped fielding a team late in that decade. (Courtesy of Elizabeth Hicks Campbell Adams.)

This birthday party for Hallie Adams took place at a home in Lakeland around 1955. The guests were, from left to right, Maseo Campbell Sr., Elizabeth Campbell, Mary Brooks Brewer, Emma Dory, Calvin Adams, Peggy Folkes, Joe Harrington, June Adams, Mattie Johnson, Katie Mae Barnes, and Helen Campbell. (Courtesy of Elizabeth Hicks Campbell Adams.)

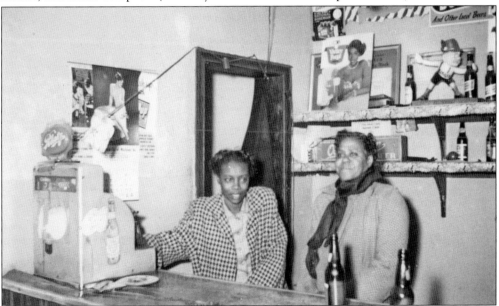

Nellie Stewart opened Stewart's Tavern in the lower level of her home on Navahoe Street in the 1940s. Made up of a barroom and screened porch with an adjacent kitchen, it was a social gathering place for African Americans, who came from as far away as the District of Columbia and Laurel. This was one of only a handful of nightspots open to the area's African Americans prior to the desegregation of public facilities in 1960. The owner's daughter, Dorothy Stewart (left), is shown here with her cousin Sarah Jackson around 1955. (Courtesy of Leonard Smith.)

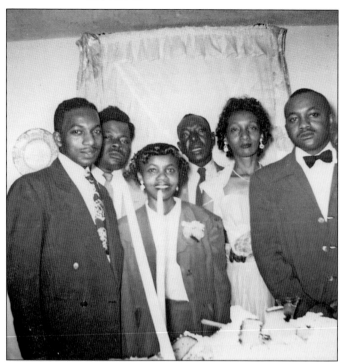

On April 5, 1953, Saxoline Briscoe married Sherman Campbell at her home on Lakeland Road. The bride's father and siblings pose with her in this picture. From left to right are Joseph Louis Briscoe, Spencer M. Briscoe, Mary Ruth Briscoe Jackson, George Phillip Briscoe (father of the bride), Saxoline Briscoe Campbell, and Joseph McDonald Briscoe. (Courtesy of Joseph Louis Briscoe.)

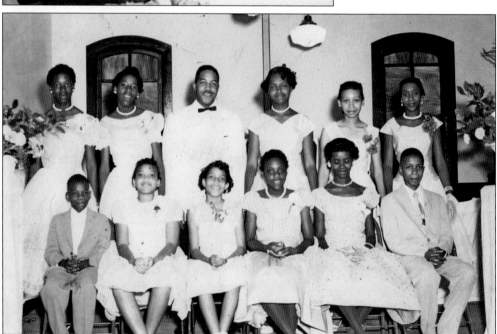

Many of the young people in the community used public transportation to travel to the District of Columbia to study piano under David Hines. For several years, the students presented a fund-raising recital at Embry AME Church. This program on June 27, 1957, included, from left to right, (first row) Reginald Keys, Rosetta Brooks, Cynthia Hines, Phyllis Smith, DeWana Gray, and Karl Alexander; (second row) Janet Randall, Jacqueline Randall, Barbara Brown, Diane Weems, and Frances Mason. (Courtesy of Jean Gray Matthews.)

In 1957, debutante DeWana E. Gray is escorted by Eugene Jordan and accompanied by her parents, Christine and Clarence Gray. The debutante ball was sponsored by the Links, an African American women's service organization. Gray was presented by Dr. David Hinton and ViCurtis Gray Hinton. (Courtesy of the Gray family.)

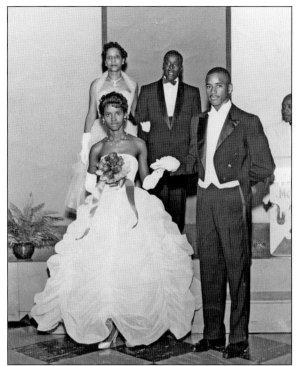

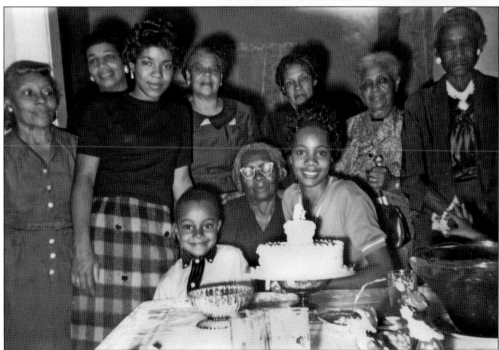

Family and friends gathered to celebrate the 70th birthday of Nellie Stewart in her Navahoe Street home. Standing from left to right are (first row) Reginald Walker, Nellie Stewart, and Vivian Marshall; (second row) Ila Mason, Sylvia Stewart, Maria Lomax Dory, Ellen Lomax Briscoe, and two unidentified; (third row) Viola Brooks Johnson. (Courtesy of the Gross family.)

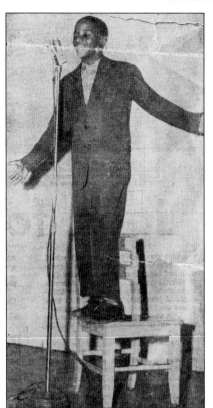

In 1957, fourteen-year-old Wardell Thomas was Lakeland's own teenage singing sensation. He was featured in a February 1957 *Washington Star* article, which applauded his ability and his winning streak at local talent shows. Thomas impressed his audiences with renderings of songs such as "In the Still of the Night" and "Why Do Fools Fall in Love?" He began his musical career at the age of six when he walked on stage and performed during a show. Thomas also sang at Embry AME Church. (*Washington Star*, [February 1, 1957] reprinted by permission of the DC Public Library, © *Washington Post*.)

Prince George's County African American Teen Club Queens appeared at an annual event in 1959. Lakeland's queen was Barbara Jean Walls (far left). The Teen Club met every Friday night at Lakeland Junior High School's multipurpose room. Chaperones included Lucille Sharps and Agnes Randall, ladies who demanded strict decorum. Diane Weems Ligon recalls the chaperones' insistence on respectable dancing between girls and boys: "They had to see air between us." The program was directed by Clement Martin, a shop teacher at the school. (Courtesy of the Randall family.)

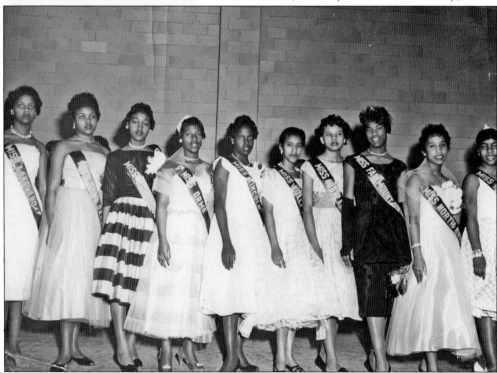

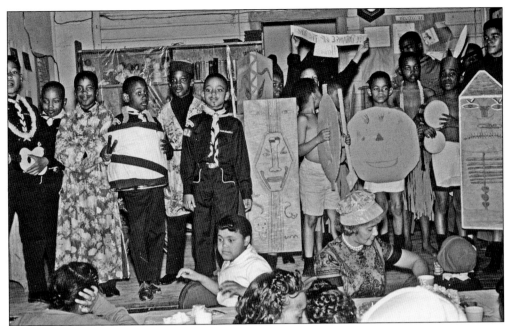

Embry AME Church was home to Cub Scout Pack 1025 for more than 20 years. The group had several den mothers, including Agnes Gross, Fannie Douglas, Vera Claiborne, and Jeanette Brooks. Their meetings and indoor activities were usually held in the church parish hall. Around 1964, the cubs presented their interpretation of life in the South Pacific to an audience of family members and friends. (Photograph © 2008 Joanne M. Braxton.)

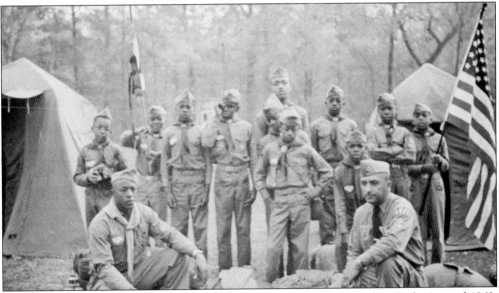

Boy Scout Pack 1025 was sponsored by the First Baptist Church of College Park. Around 1962, the pack participated in an annual camping event in Croom, Maryland. From left to right are (first row) Boy Scout leader Harold Pitts and Cub Scout den leader Harry Braxton Sr.; (second row) Garnet Fields and Roy Fields; (third row) Harry Braxton Jr., Kenneth Brooks, unidentified, Samuel Howard, and Maseo Campbell Jr.; (fourth row) Dennis Harding, unidentified, Keith Webster, and Lester Brooks with the flag. (Photograph © 2008 Joanne M. Braxton.)

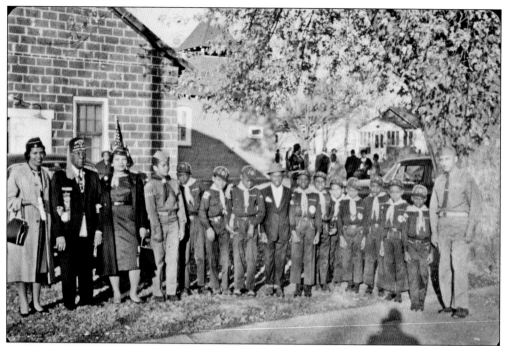

In the early 1960s, the staging area for Lakeland's parade was the grounds of Embry AME Church. The annual event, sponsored by the Elks Club, was highly anticipated by all. Lakeland's Cub Scouts are pictured here around 1962 with den mother Thelma Lomax, J. Chesley Mack in his lodge regalia, and den mother Jeanette Brooks. Cub Scout master Harry Braxton is seen at the far right. (Photograph ©2008 Joanne M. Braxton.)

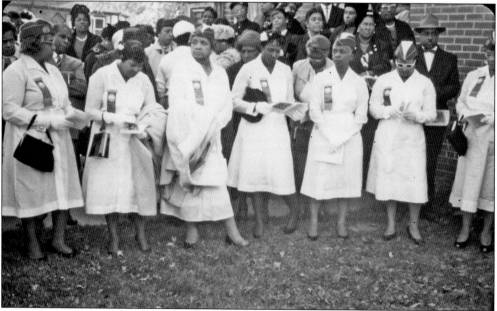

Members of the Household of Ruth, the women's auxiliary of the African American Odd Fellows order, prepared for participation in Lakeland's c. 1962 annual parade. The group was a part of community life until 2007. (Photograph © 2008 Joanne M. Braxton.)

Violetta Sharps, Miss Lakeland 1963, greets the crowd during that year's Elks Day Parade. Among the groups marching that day were Lakeland's own majorettes. This parade was one of many that took place over the years in the Lakeland. The Elks' parades promoted healthy competition between lodges throughout the District of Columbia, Maryland, and Virginia. Captured in the photograph below, marching down Lakeland Road, is one of several marching bands invited to participate. (Both courtesy Pearl Lee Campbell and James Edwards III.)

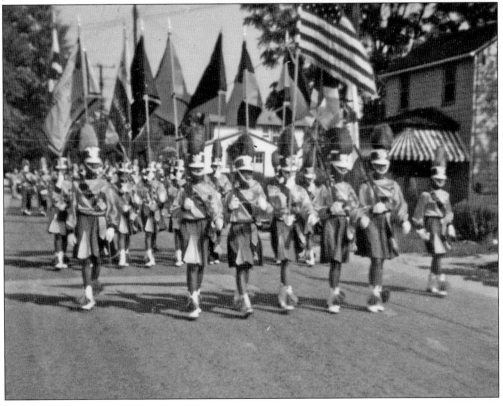

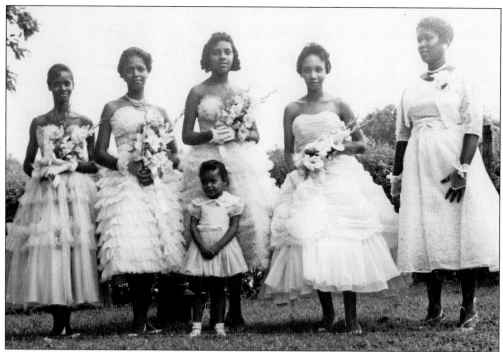

In this garden wedding during the summer of 1960, Marie née Brown and William Brown were married. The attendants were local young women, from left to right, DeWana Gray, Barbara Brown, Barbara Jean Walls, Diane Weems, and matron of honor Ethel Wilson Brown. Shirley Brown was the flower girl. (Courtesy of Jean Gray Matthews.)

On a Sunday afternoon in the 1960s, sisters Eliza and Pauline Gray relax for a moment with some of their nieces and nephews. From left to right are Myron Gray, Paul Butler, Linda Gray Butler, Eliza Gray, Mildred Gray, Pauline Gray, DeWana Gray, an unidentified friend of DeWana's, and Lester Gray. (Courtesy of the Gray family.)

Home weddings were popular during the 1950s and 1960s. Mary Day and Samuel Hollomand were married on June 20, 1962, at the home of the bride's parents. Rain forced the ceremony to be moved indoors to the living room. The Hollomands built their home and raised their family in Lakeland, where they continue to live. (Courtesy of Mary Day Hollomand.)

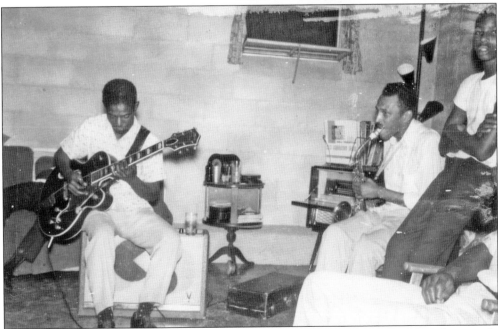

Home parties were an important part of the Lakeland social scene. In this c. 1964 photograph, Lakelander Ernest Brown (left), a former member of the Ink Spots, the popular vocal group of the 1930s, 1940s, and 1950s, and saxophonist Samuel Hollomand treat guests to a jam session. The party took place in the recreation room of the James Weems family. (Courtesy of Leonard Smith.)

Along Pierce Avenue, adjacent to the railroad tracks and under a stand of trees, was a place where gentlemen held court. Any day when the weather was fine, Luke Gray (center), having retired from the workaday world, could be found in his favorite spot paying witness to the passage of time. Frequently friends George Falls (left) and Willie Laney (right) would join him. They would sit for a while and discuss the events of the day. This photograph was taken around 1965. (Courtesy of the Gross family.)

Although public education and housing were still largely segregated in 1962, there were organizations that admitted individuals regardless of race. One such institution was the College Park Boys Club. In their sports programs, boys were able to learn, play, and compete with peers from neighboring communities. Several Lakelanders are included in this photograph of the club's track and field program. (Courtesy of Dwight Brooks.)

James Walter Edwards III and Pearl Lee Campbell were married on Saturday, March 14, 1964. Their reception was held in the parish hall of Embry AME Church, where both of them had also been baptized. When the church sanctuary was renovated in the 1980s, the couple saved one of its stained-glass windows. They commissioned an artist to combine some of the glass with their marriage certificate to form a unique keepsake. (Courtesy of Pearl Lee Campbell and James Edwards III.)

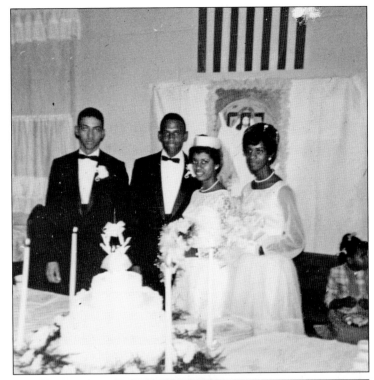

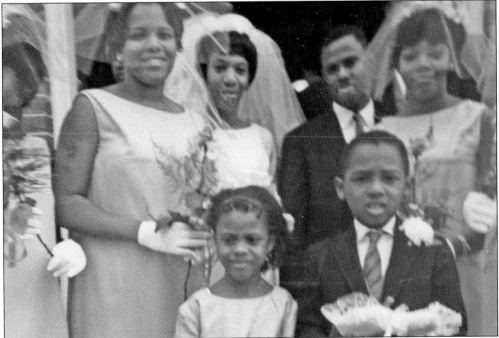

On October 15, 1966, Pamela Randall became the bride of James Boardley at Embry AME Church. Their wedding party included, from left to right, (first row) flower girl Secethia Boardley and ring bearer Robert Fields Jr.; (second row) Sandra Randall, Sandra Douglas, Pamela Randall Boardley, James Boardley, and Sylvia Mizell. (Courtesy of the Randall family.)

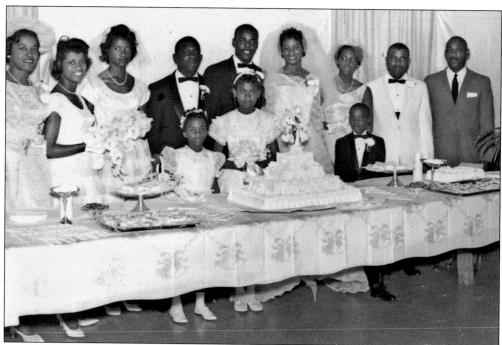

Lakelanders George Smith and Mary Ann Campbell began their married life on Saturday, June 5, 1965, at Embry AME Church. The bride chose to honor her grandmother Ethel Hicks Claiborne by selecting her birthday as the date for her nuptials. During the reception in the church parish hall, the wedding party assembled for the photograph above. Theirs was the perfect June wedding held on a fine sunny day, and the parish hall was filled to capacity with well-wishers. Below, many of the ladies were crowned in lovely spring hats. (Both courtesy of Elizabeth Hicks Campbell Adams.)

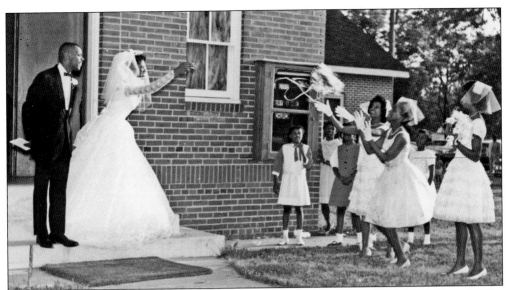

Newlywed Mary Ann Smith tosses her bouquet from the steps of Embry AME Church. The recipient was her maid of honor, Yvonne Dorsey, a former classmate of the bride at Fairmont High School. (Courtesy of Elizabeth Hicks Campbell Adams.)

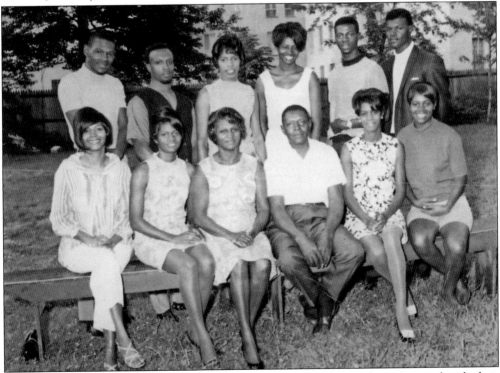

Edward Jefferson Potts and his wife, Amy Brooks Potts (seated center), are pictured with their children; from left to right, (seated) Beverly, Patricia, Iris, and Sylvia; (standing) Anthony, Edward, Shirley, LaVerda, William, and Gerald. Wallace was not present for this photograph, which was taken at the Potts family home on Navahoe Street around 1968. Potts was a granddaughter of Samuel and Georgianna Stewart, founders of Embry AME Church. (Courtesy of Iris Potts-Thompson.)

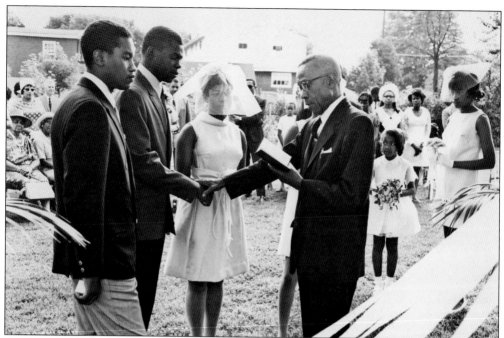

William "Billy" Jones and Violetta Sharps were united by Rev. Robert H. Baddy at the bride's home on July 6, 1968. The ceremony is witnessed by the best man, bridal attendants, family members, and friends. The couple met while attending the University of Maryland. Jones was one of the first African Americans to receive a basketball scholarship from the university and is credited with integrating Atlantic Coast Conference athletics. (Courtesy of Violetta Sharps Jones.)

Duckpin bowling was a favorite American pastime during the 1960s and early 1970s. Members of the Lakeland community played in a number of leagues at College Park's Fairlanes Bowling Center. The awarding of trophies and the annual banquet were eagerly anticipated events among the bowlers. Pictured here are, from left to right, James Hill, Helen Swan Hill, Lois Gilbert, and Thomas Randall. (Courtesy of the Randall family.)

Embry AME Church was the site for the wedding of Kathleen Campbell and James Tyrone Kennedy on September 9, 1972. The pair grew up in Lakeland, attended church, and went to school together. Their clothing and hairstyles reflect the height of fashion for that period. (Courtesy of Elizabeth Hicks Campbell Adams.)

Family and friends gathered for a birthday celebration for Alberta Tolson on July 4, 1978. The party was held at the home of Tolson's daughter, Bernice Smith, in an apartment above Mack's Market. Tolson (seated) is shown with her daughters: from left to right, Dorothy Holman, Geraldine Jackson, Eleanor Green, and Bernice Smith. (Courtesy of Barbara Brown Seldon.)

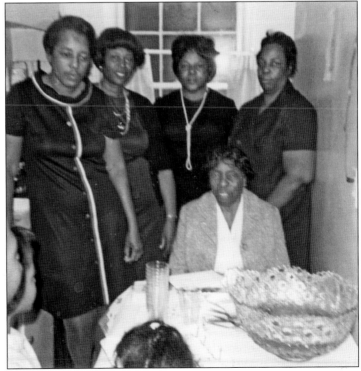

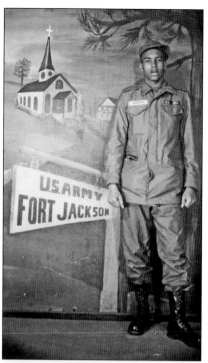

As a young man, Lakelander Donald Weems, son of James and Mary Weems, was so moved by the racism he experienced while in the U.S. Army, he developed a new way of looking at his role in the world. Weems took the name Kuwasi Balagoon, which in Yoruban means "son of the warrior god born on Sunday." The name mirrors the way in which he saw himself: as a solider in the army for black liberation. Balagoon was a leader in the Black Panther Party and an internationally published poet and essayist. (Courtesy of Diane Weems Ligon.)

In 1990, James and Mary Weems cut the cake during their 50th wedding anniversary celebration. They renewed their vows and hosted a dinner with dancing for 125 family members and friends. Their wedding had been a private event at the courthouse in Upper Marlboro, Maryland. Both James and Mary were born in Lakeland and were products of the Lakeland schools. They remained in the community for the 66 years of their marriage. Their surviving children still live in Lakeland. (Courtesy of Diane Weems Ligon.)

Eight

A DREAM DENIED

In the early 1960s, Lakeland was one of a handful of largely self-contained African American communities in Prince George's County, Maryland. Lakeland's neighboring communities were populated overwhelmingly by whites. African Americans were confined by tradition and discriminatory housing policies to specific communities. Here is the central section of Lakeland Road around 1965. Embry AME Church is on the right, and First Baptist Church is to the left, just out of view. (Courtesy of the City of College Park.)

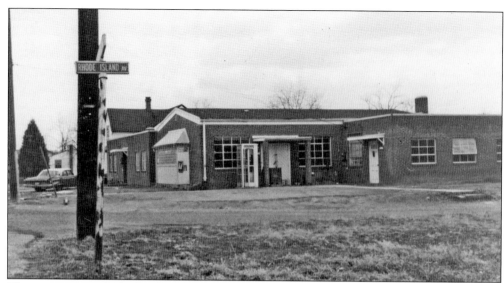

The intersection of Rhode Island Avenue, Lakeland Road, and Navahoe Street was the hub of Lakeland. Electric streetcars connected the community with the District of Columbia from 1895 until 1958. Mack's Market, Black's Store, the Elks Home, Lakeland Hall, and Miss Waller's Beauty Parlor were located near the streetcar stop. Black's Store, shown here around 1969, was owned by Charles Black. It had four apartments, a dry cleaner, and a beauty parlor, along with a store that sold groceries and snacks. With a lunch counter and jukebox, the establishment became a popular place for teens to gather, eat, dance, and enjoy being together. (Courtesy of Thelma Lomax.)

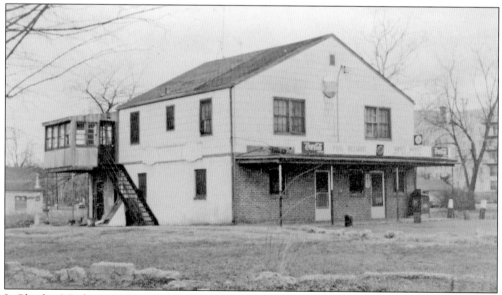

J. Chesley Mack, sometimes referred to as the unofficial mayor of Lakeland, operated Mack's Market on Rhode Island Avenue. It was a general store with an ice cream counter and billiard parlor on the main floor and rental apartments on the second floor. Mack also worked as a chef at the University of Maryland and served as Lakeland's City Council representative from 1945 until 1957. (Courtesy of Thelma Lomax.)

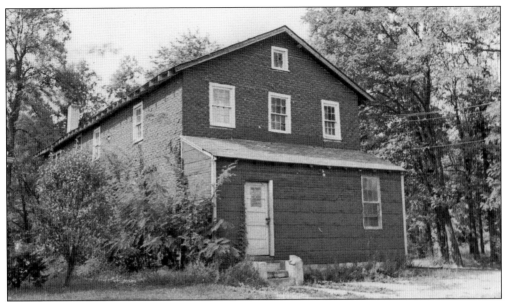

With the limited access African Americans had to public spaces until the 1960s, this building on western Navahoe Street served a multitude of functions. It was designated "Lakeland's Hall," a place for public meetings, dances, wedding receptions, and church services. On Saturday, it became a movie theater. The building is shown here around 1965. This hall replaced an earlier structure located in the central section of the community. Both buildings on this page along with all structures in the eastern and western sections of Lakeland were demolished as a result of an urban renewal project. (Courtesy of Thelma Lomax.)

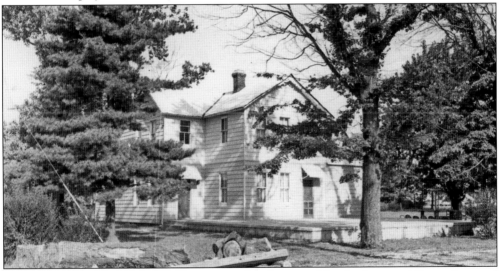

The Elks Home, here around 1965, was owned and operated by the Improved Benevolent and Protective Order of Elks. The organization was created in 1899 in answer to the exclusion of African Americans from the Benevolent and Protective Order of Elks. To raise funds for their charitable and social endeavors, the group hosted regular events that were open to those living in Lakeland and the surrounding communities. Most fondly remembered are the annual carnivals held on the grounds of the building and the parades through the streets of Lakeland. This building was located in the western section of Lakeland. (Courtesy of Thelma Lomax.)

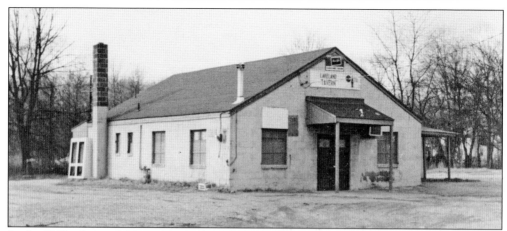

In the 1940s, Stewart's Tavern opened in Nellie Stewart's home on western Navahoe Street. In the 1950s, her son Henry Conway, a brick mason, and some of his friends built a separate structure next door for the establishment. They renamed it Four Brothers Tavern. When the business was sold to Leonard Smith in the mid-1960s, it became known as Lakeland Tavern. The building was razed in the 1970s, not long after this photograph was taken, to make way for Lakeland's federally funded urban renewal project. (Courtesy of Thelma Lomax.)

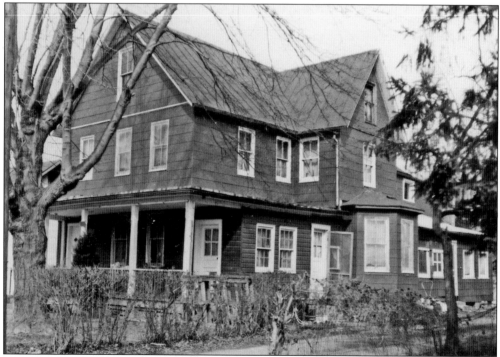

One of Lakeland's larger houses is pictured above. Located on western Navahoe Street, it was purchased by Richard and Mary Walls in 1925 and used as a rooming house. Property records note this parcel as being a multi-living unit on multiple lots. This part of Lakeland between U.S. Route 1 and Rhode Island Avenue was the most densely populated area and was frequently challenged by flooding. In the early 1960s, community leaders sought help from their city government to solve the flooding problem and to help some residents renovate their homes to meet modern standards. (Courtesy of Thelma Lomax.)

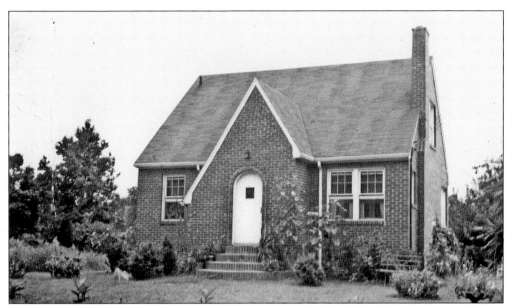

In 1935, Nancy Gross Tabbs built this house on Augusta Avenue (now Navahoe Street) for her daughter, Janine, and herself. Viola Gross and Margaret Gross Gray, Tabbs's nieces, later inherited the home as it is pictured here in the 1950s. In 1989, a great-great-niece of Tabbs purchased the home from her great-aunt's estate. (Courtesy of the Gross family.)

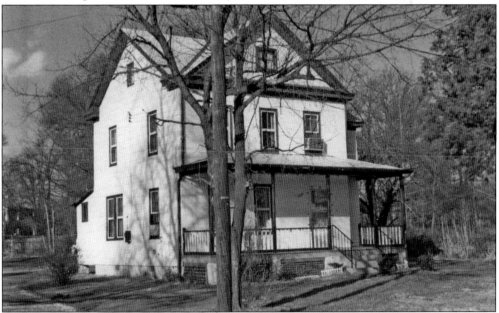

The Dory family home is one of the oldest houses remaining in Lakeland. Around the dawn of the 20th century, Charles Dory moved this building from College Avenue in Old Town College Park to its current location on Navahoe Street. For the past 100 years, the home has been continually owned and occupied by family members. In the 1940s, the Dorys were the first family on the street to have a telephone. They accepted calls for the whole neighborhood. Emma Dory, wife of Charles Dory, would shout from her porch or send a young family member to inform neighbors when a telephone call came for them. (Courtesy of Thelma Lomax.)

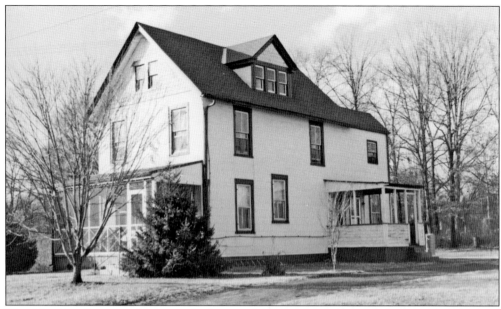

This Navahoe Street residence was built around 1900 and is believed to be one of the original houses built by Lakeland developer Edwin Newman. This house was once home for Leonhard and Elizabeth Exel, German immigrants who were the last white family to leave the community in the late 1940s. The home was purchased by Thomas and Agnes Randall in 1951. Since that time, it has sheltered three generations of their family. The home was a frequent gathering place for the youngsters of Lakeland. (Courtesy of Thelma Lomax.)

In 1946, Maseo Campbell built this home on Navahoe Street, and he and his wife, Elizabeth, raised their six children there. Campbell's first cousin Willie Campbell occupied the house to the left. First cousins Mary and Wilbur Brower lived in a house to the right, just out of view. (Courtesy of Elizabeth Hicks Campbell Adams.)

In 1940, James Walter Edwards Jr. moved his family into this home on Albany Avenue, east of the Baltimore and Ohio Railroad tracks. After the Christmas holiday that year, Edwards planted the Christmas tree used in his living room, along with one used in a friend's celebration. These transplanted trees dwarf the Edwardses' house in this 1960s photograph. The home was demolished in the mid-1970s as part of the urban renewal project. (Courtesy of Pearl Lee Campbell and James Edwards III.)

George and Jeanette Brooks built this house in 1955 on Lakeland Road. It was a new and modern home for a growing family. They lived here for only about 20 years, before the house fell victim to the late 1970s urban renewal project. (Courtesy of Thelma Lomax.)

In 1970, Prince George's County officials reported that only a few of Lakeland's streets were paved, lighting was inadequate, and home values lagged behind those of neighboring white communities. The report failed to mention contributing influences, such as the disparity in economic prospects and the lack of financing opportunities for residential and commercial properties. African Americans were primarily dependent on unregulated private lenders; bank mortgages were rarely granted. Above are two homes on Pierce Avenue around 1965. On the left is the home of Willie Laney and his wife, Arlene; to the right is the home built by Elwood Gross and his wife, Wilmer, in 1962. Below are two homes on Lakeland Road around 1968. (Both courtesy of Thelma Lomax.)

Harry M. Braxton; his wife, Mary; their children; and his mother, Emma Harrison, shared a home in the Lakeland community. Harry Braxton was head of the local Human Relations Council, a racially integrated social change organization. He also was director of public relations for the Prince George's County National Association for the Advancement of Colored People. Family members were deeply involved in the civil rights movement and all aspects of community life. One Sunday morning, when Braxton's wife and mother were alone at home while Braxton attended church services, two youths from a nearby white community fired 44 bullets into the family's home. (Photograph © 2008 Joanne M. Braxton.)

Once vacated, several of Lakeland's homes were burned as training exercises for the local fire department. Here is a photograph of one such incident. (Photograph © 2008 Joanne M. Braxton.)

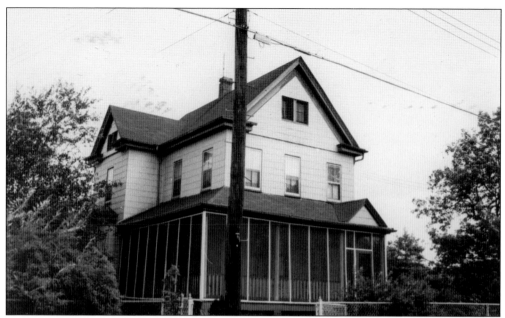

Oral history tells us that this home was built as part of developer Edwin Newman's grand plan for Lakeland. It was prime property on the shore of Lake Artemesia. This house was home to a family headed by Cuban immigrant Marcelino Cordove. For several years, the family operated a lodging business with modest "tourist homes" located adjacent to the house. Like all the other homes in Lakeland's eastern area, it was demolished to make way for urban renewal efforts. (Courtesy of Thelma Lomax.)

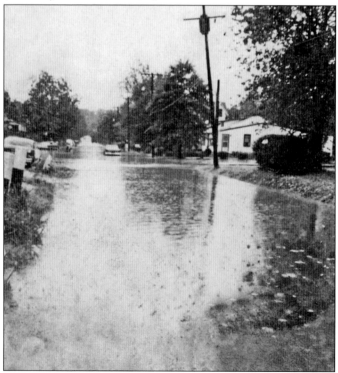

The western section of Lakeland frequently flooded after a heavy rain, as shown in the photograph at left. On June 23, 1972, Tropical Storm Agnes devastated Lakeland and much of the region. Floodwaters covered the entire community, damaging many homes and destroying several others. Following the storm, efforts to obtain effective flood control and redevelopment were taken up with a new urgency. Finally, a flood control project by the Army Corps of Engineers was approved, and the Lakeland Urban Renewal Project began to receive necessary governmental approvals for work to begin. (Courtesy of the City of College Park.)

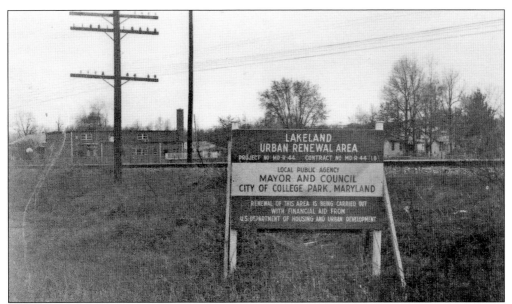

In 1961, College Park officials recognized the need to improve and renovate some of Lakeland's homes, many of which had been damaged by the frequent flooding. To carry out the improvements, city officials adopted an urban renewal plan in 1970. It mandated redevelopment of Lakeland's eastern and western sections, about two-thirds of the community. Residents of the affected areas vacated their homes in the mid-1970s. They were compensated for the value of their homes and promised an opportunity to return to new housing units when construction was completed. The project was expected to take a few years. However, it took much longer because problems plagued the project, thanks to changes in regulations and policies within the federal government resulting in numerous delays. Over time, economic forces and other issues produced vast changes in the redevelopment plan. The "Urban Renewal" notice shown above and the ruins of homes, such as those along a section of Lakeland Road (pictured below), blighted the community for more than five years. (Both courtesy of the Gross family.)

Neighbors helping neighbors to build and maintain their homes is a tradition in the community of Lakeland. Above, James Clemmons is shown in the central section of Lakeland, on Pierce Avenue, preparing the foundation for the new home of friends Julia and Harold Pitts. The Pittses had lived on the western section of Lakeland Road but were displaced by the urban renewal project. (Courtesy of Julia Pitts.)

By 1981, the rebuilding of Lakeland was at last underway. A process that was expected to take a few years was plagued by bureaucratic problems and policy changes. In fact, rebuilding took decades. Single-family homes were ultimately replaced with high-rise apartment buildings and townhomes. The lake in the eastern section was enlarged, and that area became a park. Only a few single-family homes were built. (Courtesy of the City of College Park, Maryland.)

Nine

THE DREAM RENEWED

The 38-acre Lake Artemesia Natural Area opened as a public facility in 1992. Located in what was once the eastern section of Lakeland, it features aquatic gardens, fishing piers, and trails. The new Lake Artemesia is the product of builders dredging for gravel to elevate the rail bed that would carry commuter trains along Washington Metrorail's Green Line. Once the excavation was finished, the area was redeveloped and given to the local parks authority. The park stands on the former site of 30 Lakeland homes. (Courtesy of the Gross family.)

At the end of the urban renewal process, Lakeland had its first community park. Developed along the south side of Lakeland Road, it includes a pavilion, basketball and tennis courts, and a playground. There are trail links to Lake Artemesia, the Paint Branch Trail, and Anacostia trails. On opening day, July 30, 1983, participants came from all parts of the community to celebrate, including members of St. Andrew Kim Catholic Church, which had purchased the historic building that once housed Lakeland High School. Members of the church's performance group posed above with other event participants. In the rear are, from left to right, state delegate James Rosapepe, Mayor Alvin Kushner, College Park City Council members Joseph Page and Anna Owens, and event organizers Thelma Lomax and Michael Middleton. Below, is a group engaged in a game of horseshoes in the park. They are George Stewart, unidentified in baseball cap, Thomas Randall Sr., Rose Cager Adams, and two unidentified individuals. (Both courtesy of Thelma Lomax.)

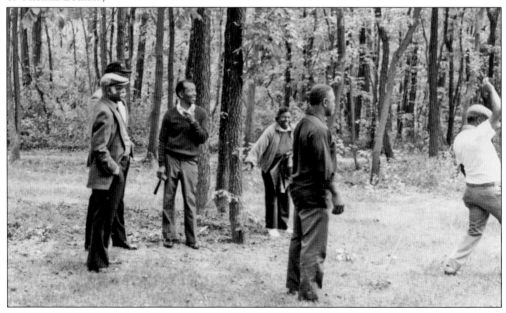

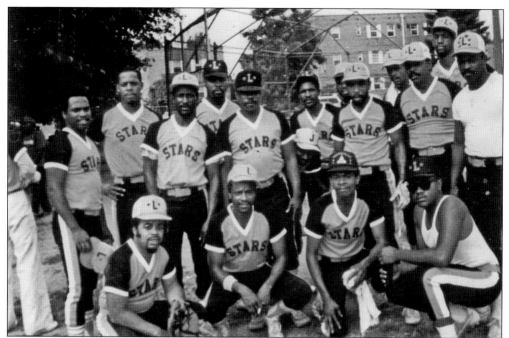

With the leadership of their coaches, Ambrose Green and Spenser Briscoe Sr., the Lakeland Stars baseball team won their league championship in 1986. This was one of the last years the community fielded a team. Team members are, from left to right, (first row) George Johnson, Eugene Briscoe, Spenser Briscoe Jr., and Louis Briscoe; (second row) Guy Weems, Abby Pennell, Francis Smith, Hubert Nickerson, George Tyrone Mondel, Warren Hill, George Smith, Sherman Campbell, and Herbert Hill. (Courtesy of Wilhelmina Johnson.)

James Adams Park is located on Navahoe Street and Rhode Island Avenue, in the heart of the Lakeland community. This tranquil spot was dedicated in 1995 in honor of one of Lakeland's avid ecologists and landscapers. Adams was a past president of the Lakeland Civic Association and an active member of the city's Committee for a Better Environment. (Courtesy of Thelma Lomax.)

Members of the Lakeland High School class of 1950 are pictured here in 2000 on their class reunion trip to Wildwood, New Jersey. These classmates have maintained lifelong friendships. They meet and socialize regularly at several members' homes, which they call "clubhouses." The group enjoys evenings out, picnics, and trips together. They also sponsor the Edgar A. Smith Scholarship—named for Lakeland High School's longtime principal—an award given to graduates of local high schools. (Courtesy of Bettye Queen.)

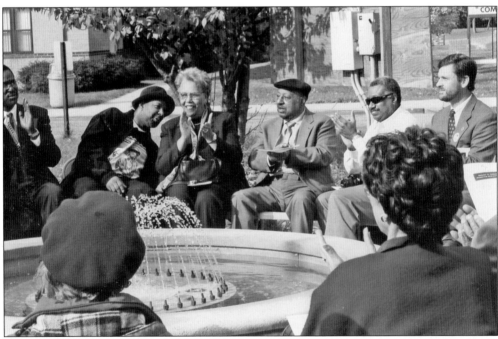

On November 9, 2002, the City of College Park honored former mayor and city councilman Dervey A. Lomax for his 28 years of service to the community. A fountain in the plaza between Paint Branch Elementary School and College Park Community Center was erected and named in his honor. Present for the dedication were, from left to right, Rev. Stephen L. Wright, Elston Lomax, Thelma Lomax, Dervey A. Lomax, Gregory Lomax, and College Park mayor Stephen Brayman. (Courtesy of Thelma Lomax.)

Members of the congregation of the First Baptist Church of College Park gathered for this photograph in June 2006, during the celebration of their 116th anniversary. Their pastor, Rev. Stephen L. Wright Sr., is second from the left in the second row. His wife, Linda, is to his left. (Courtesy of Eleanor V. Holt.)

The 2007 Smith family reunion was held in Lakeland Community Park, as it is every other year. In alternate years, the family reunion is held in Pittsburgh, Pennsylvania. Several members of the family continue to live in Lakeland, and many others still consider Lakeland their home. Family members traveled from as far as Texas to attend the 2007 reunion. (Courtesy of Julia Pitts.)

On Sunday, September 22, 2008, more than 200 people gathered at the "heart of Lakeland," the intersection of Lakeland Road and Fifty-first Avenue, between two historic churches for Lakeland Heritage Day, a time of celebration and remembrance. The focus for that year's celebration was the importance of religious life in the heritage of Lakeland. The featured event of the festivities was an outdoor worship service with participants from all of Lakeland's churches: the First Baptist Church of College Park, the Embry African Methodist Episcopal Church, the Washington Brazilian Seventh-day Adventist Church, and the Salvation African Methodist Episcopal Zion Church. Pastor David Barrozo of the Washington Brazilian SDA Church and the Reverend Dr. Edna Canty Jenkins of Embry AME Church were photographed during the event. Below, the Voices of Embry performs during the service. Choir members are, from left to right, Valarie Hill, Jeanette Williams, Abigail Cohen, Ethel Lockerman, and Diann Sims-Dwight. (Both courtesy of Christopher Anderson/*The Gazette*.)

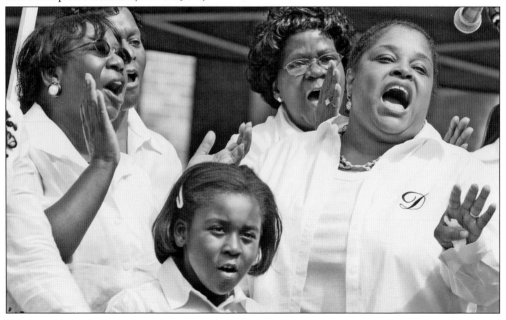

A View from the Lakes
History of the African American Community of Lakeland

CELEBRATION! BLACK HISTORY MONTH 2009

The Lakeland Community Heritage Project worked with the Maryland-National Capital Park and Planning Commission to produce the exhibition A View from the Lakes: A History of the African American Community of Lakeland. The exhibit was mounted at Montpelier Cultural Arts Center in Laurel, Maryland, in February 2009. Photographs and memorabilia were used to tell the community's story, emphasizing the strong religious, educational, and cultural ties that evolved and have sustained the community for nearly 120 years. (Courtesy of the Maryland-National Capital Park and Planning Commission.)

ACROSS AMERICA, PEOPLE ARE DISCOVERING SOMETHING WONDERFUL. *THEIR HERITAGE.*

Arcadia Publishing is the leading local history publisher in the United States. With more than 5,000 titles in print and hundreds of new titles released every year, Arcadia has extensive specialized experience chronicling the history of communities and celebrating America's hidden stories, bringing to life the people, places, and events from the past. To discover the history of other communities across the nation, please visit:

www.arcadiapublishing.com

Customized search tools allow you to find regional history books about the town where you grew up, the cities where your friends and family live, the town where your parents met, or even that retirement spot you've been dreaming about.